Masterpieces of G.F. Watts (1911)

ISBN-13 : 978-1512341195
ISBN-10 : 1512341193
Copyright©2012-2014 Iacob Adrian
All Rights Reserved.

Notice

This documentary study use historic, archived documents.

Because of this, some pages may look blurry or low quality.

Still are included in this book because they have

high value from critical, documentary, historical,

informative and journalistic point of view .

Dtp
and
visual art

Iacob Adrian

MASTERPIECES

OF

G. F. WATTS

(1817-1904)

Sixty reproductions of photographs by Fredk. Hollyer from the original oil paintings: special permission for their publication in this book has been kindly accorded by Mrs. Watts

Author statement

This is a series of art books .

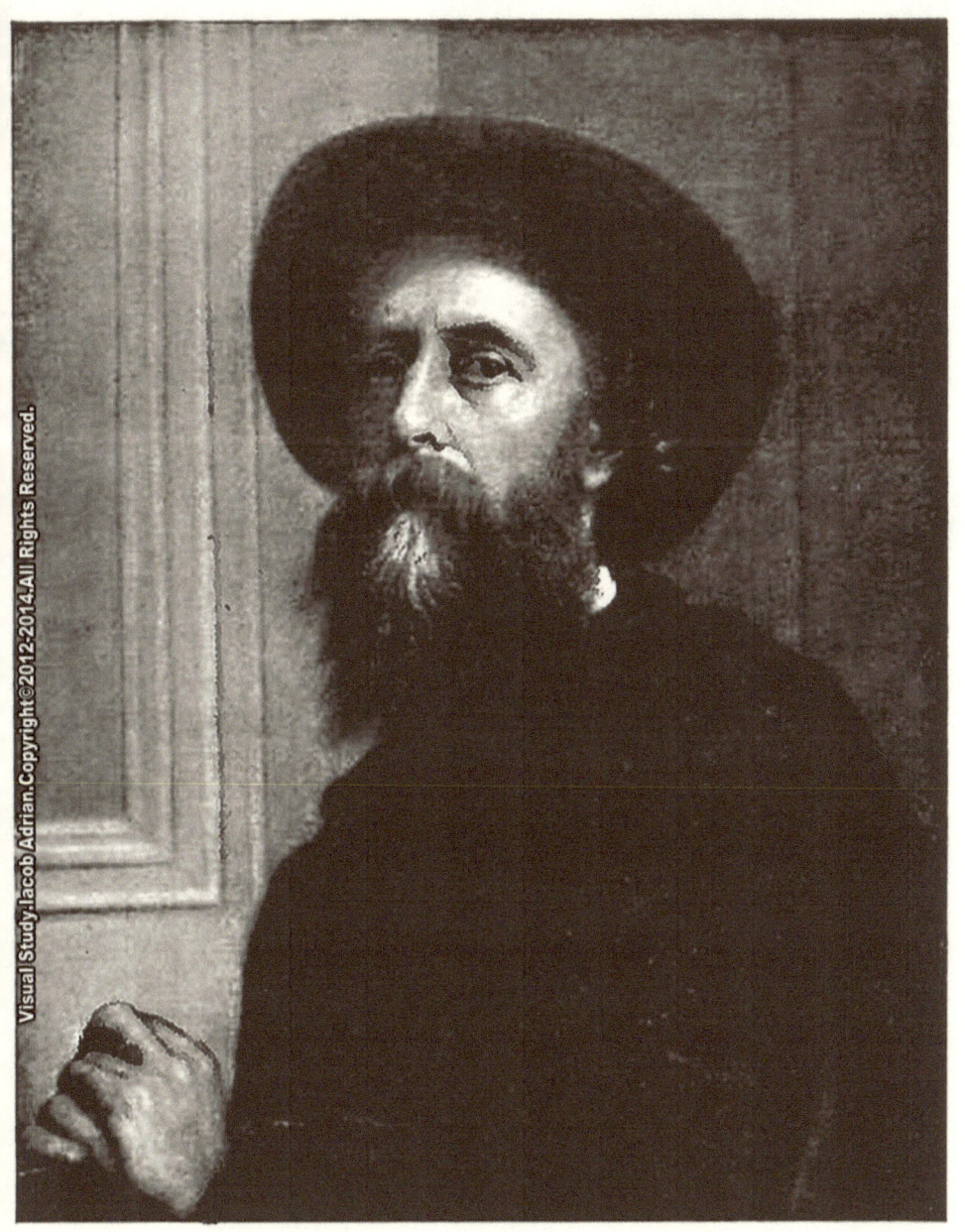

PORTRAIT OF HIMSELF PORTRAIT DE L'ARTISTE
SELBSTBILDNIS
(Tate Gallery, London)
F. Hollyer, Photo.

This little Book conveys the greetings of

..

to

..

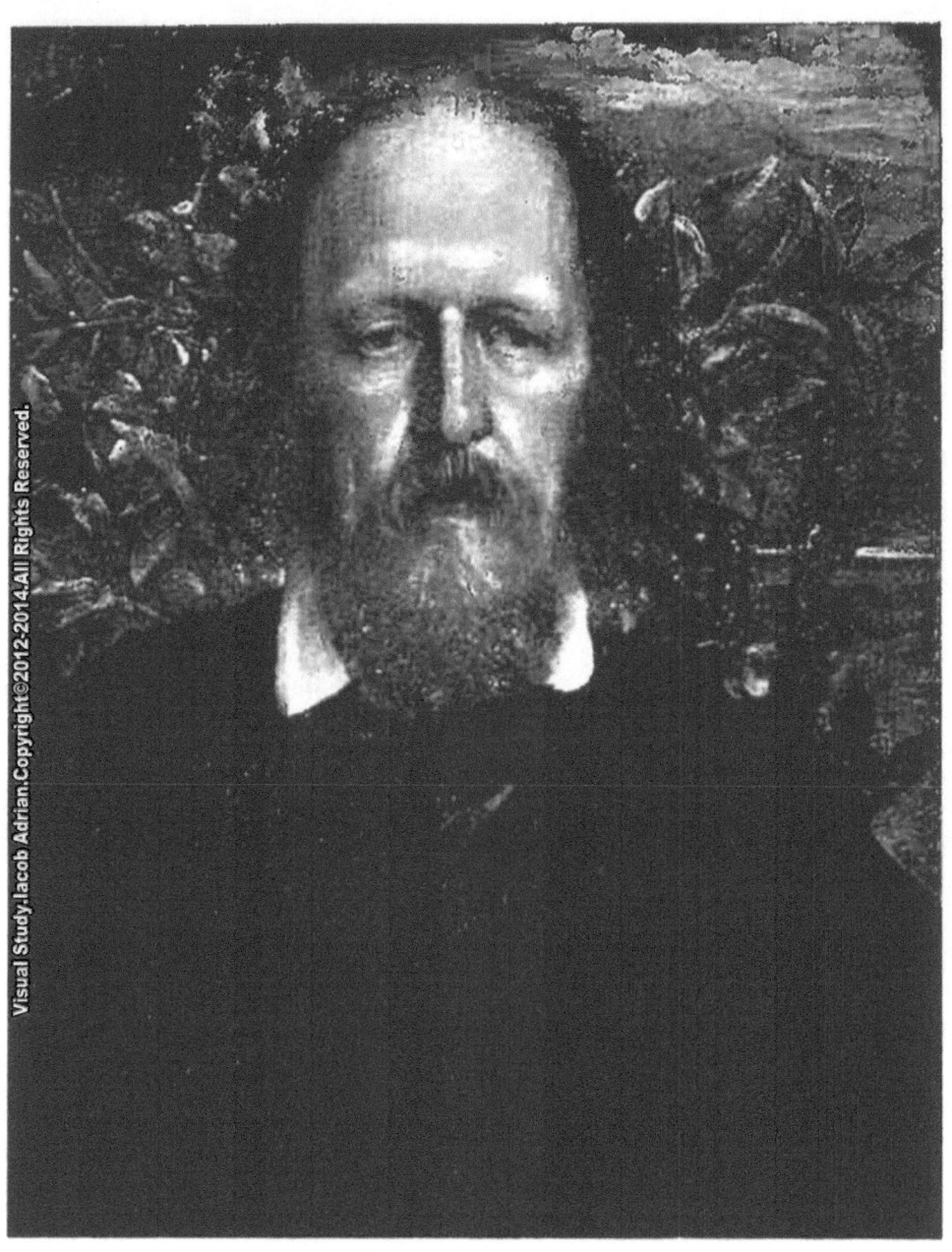

LORD TENNYSON
(National Portrait Gallery, London)
F. Hollyer, Photo.

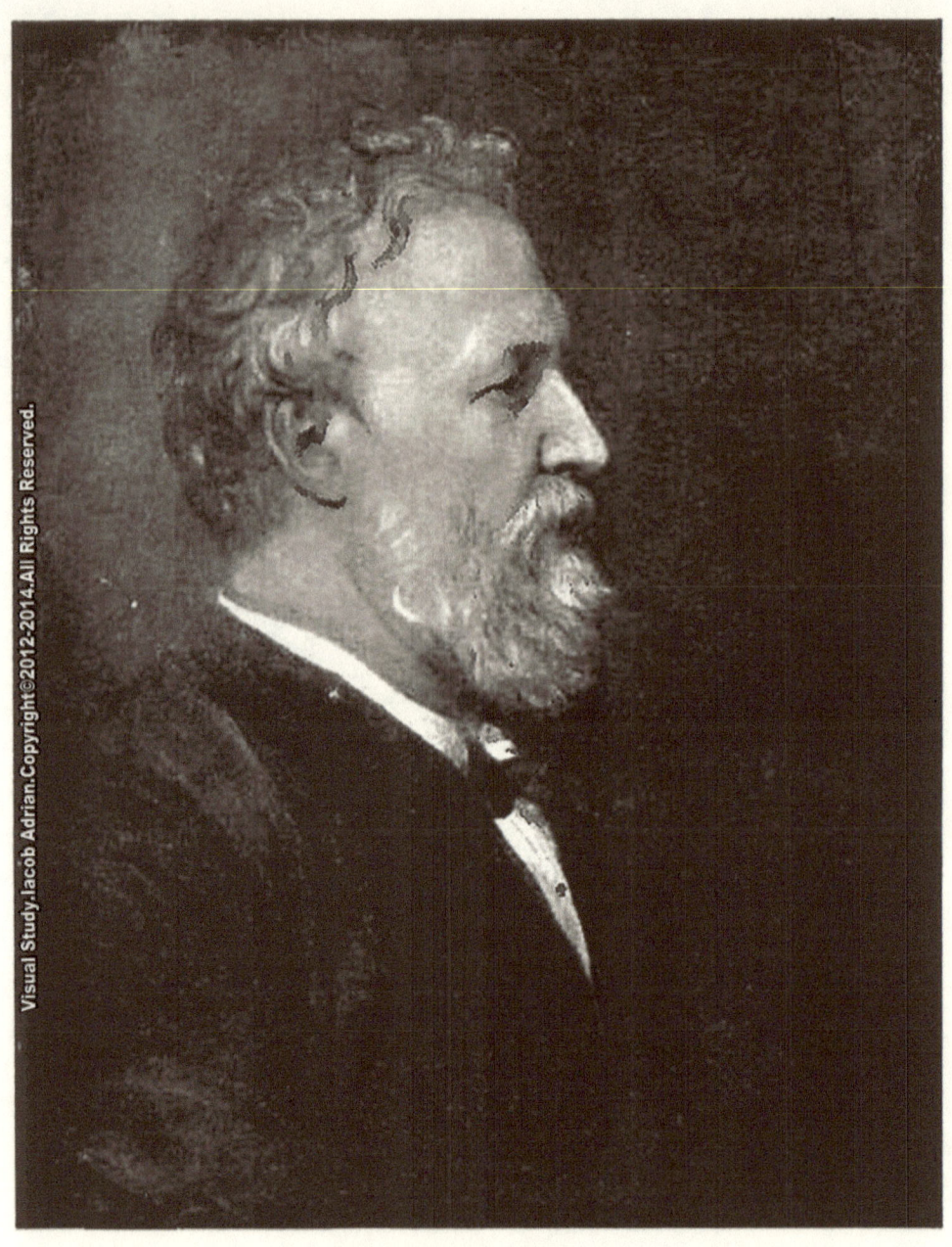

ROBERT BROWNING
(*National Portrait Gallery, London*)
F. Hollyer, Photo.

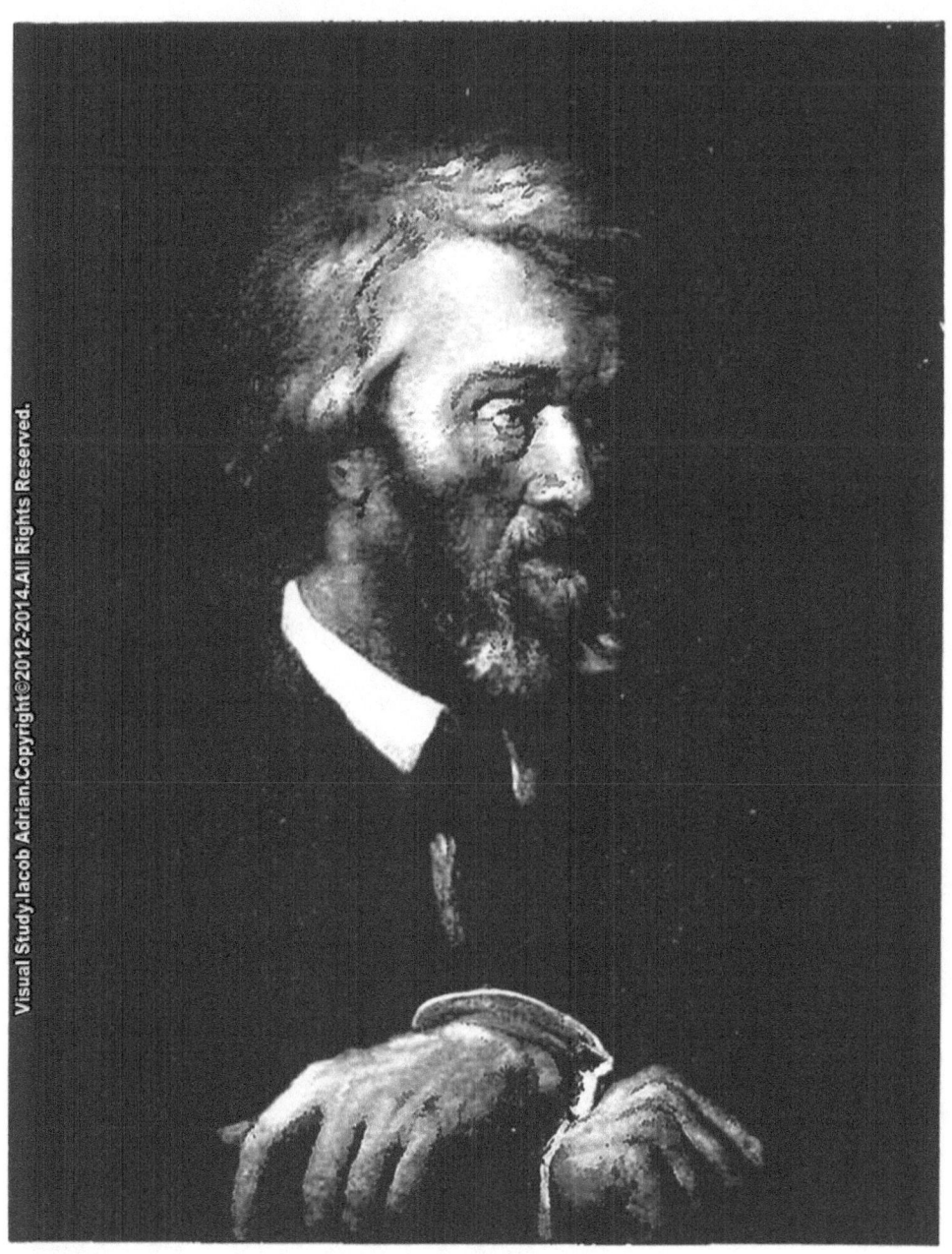

THOMAS CARLYLE
(*Victoria and Albert Museum, South Kensington*)
F. Hollyer, Photo.

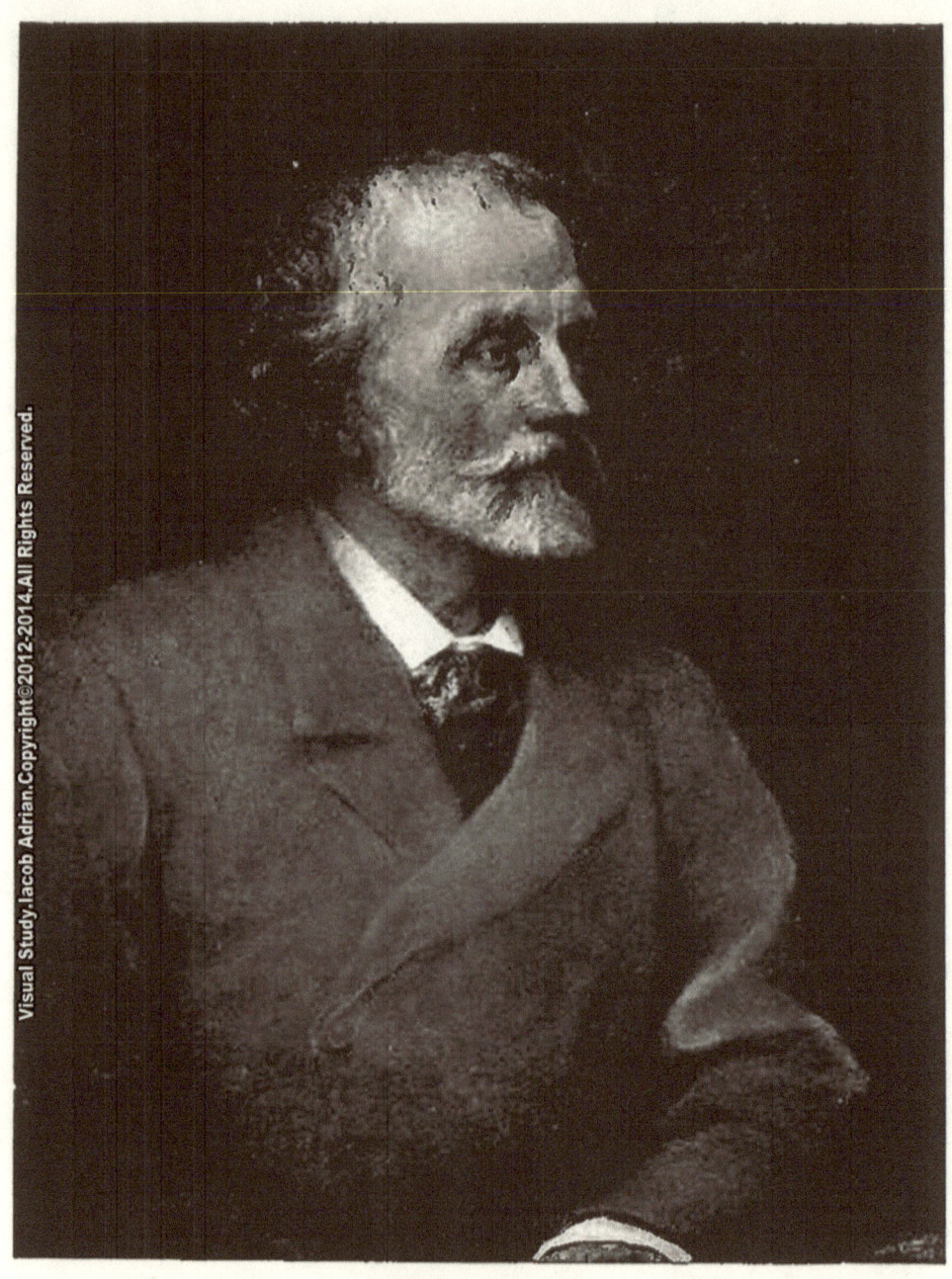

GEORGE MEREDITH
(*National Portrait Gallery, London*)
F. Hollyer, Photo.

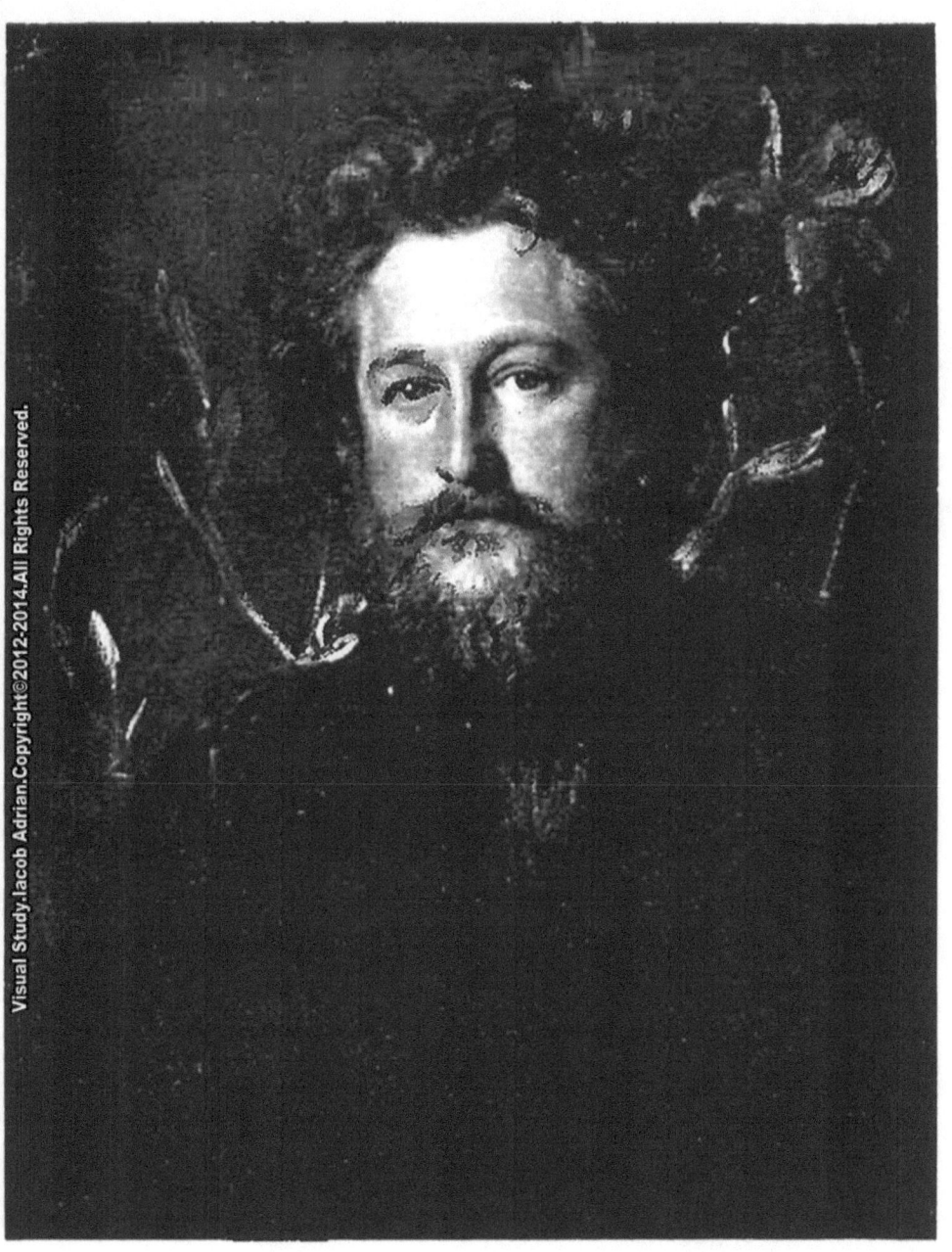

WILLIAM MORRIS
(*National Portrait Gallery, London*)
F. Hollyer, Photo.

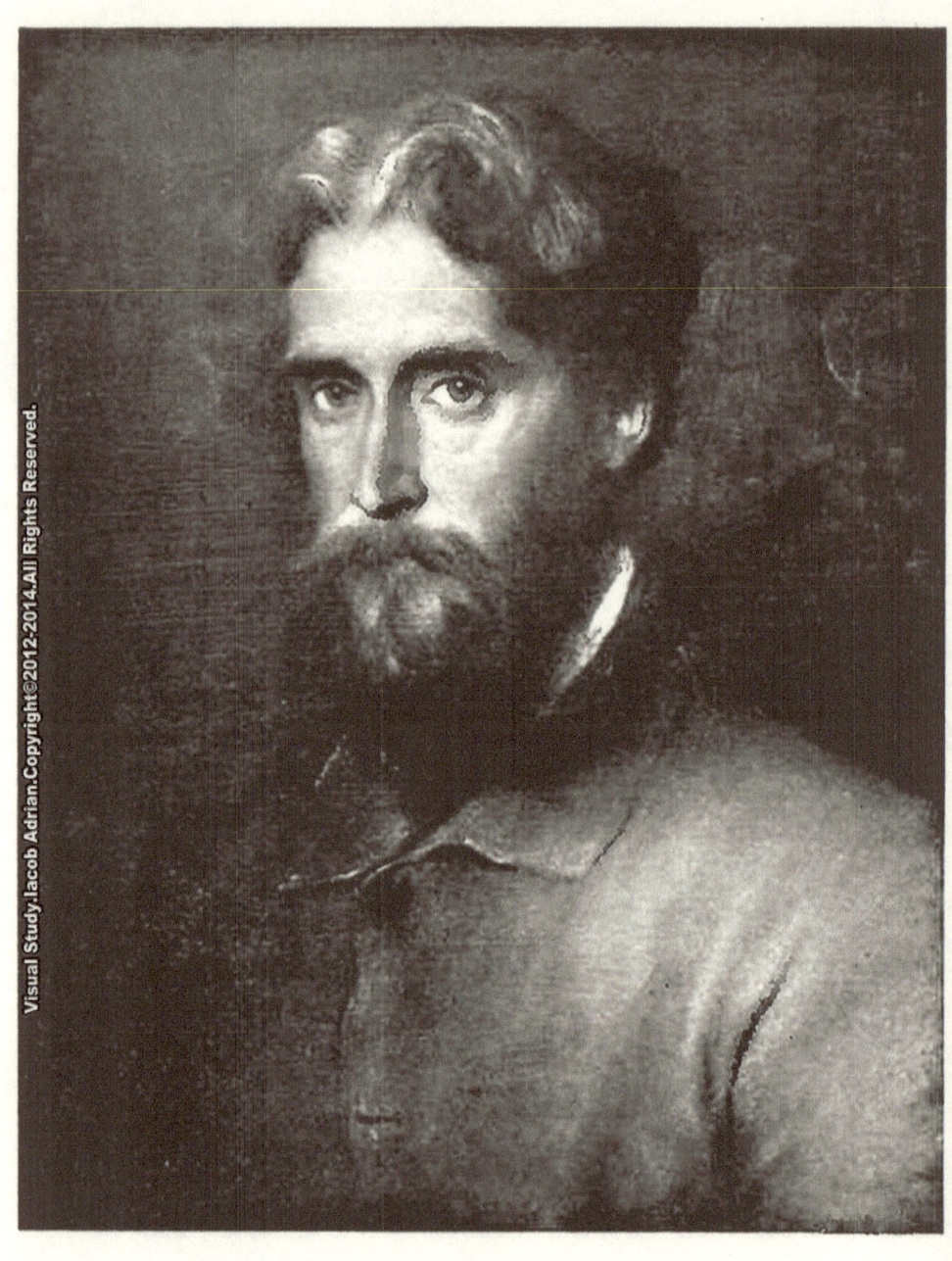

JOHN LOTHROP MOTLEY
(*Art Gallery, Manchester*)
F. Hollyer, Photo.

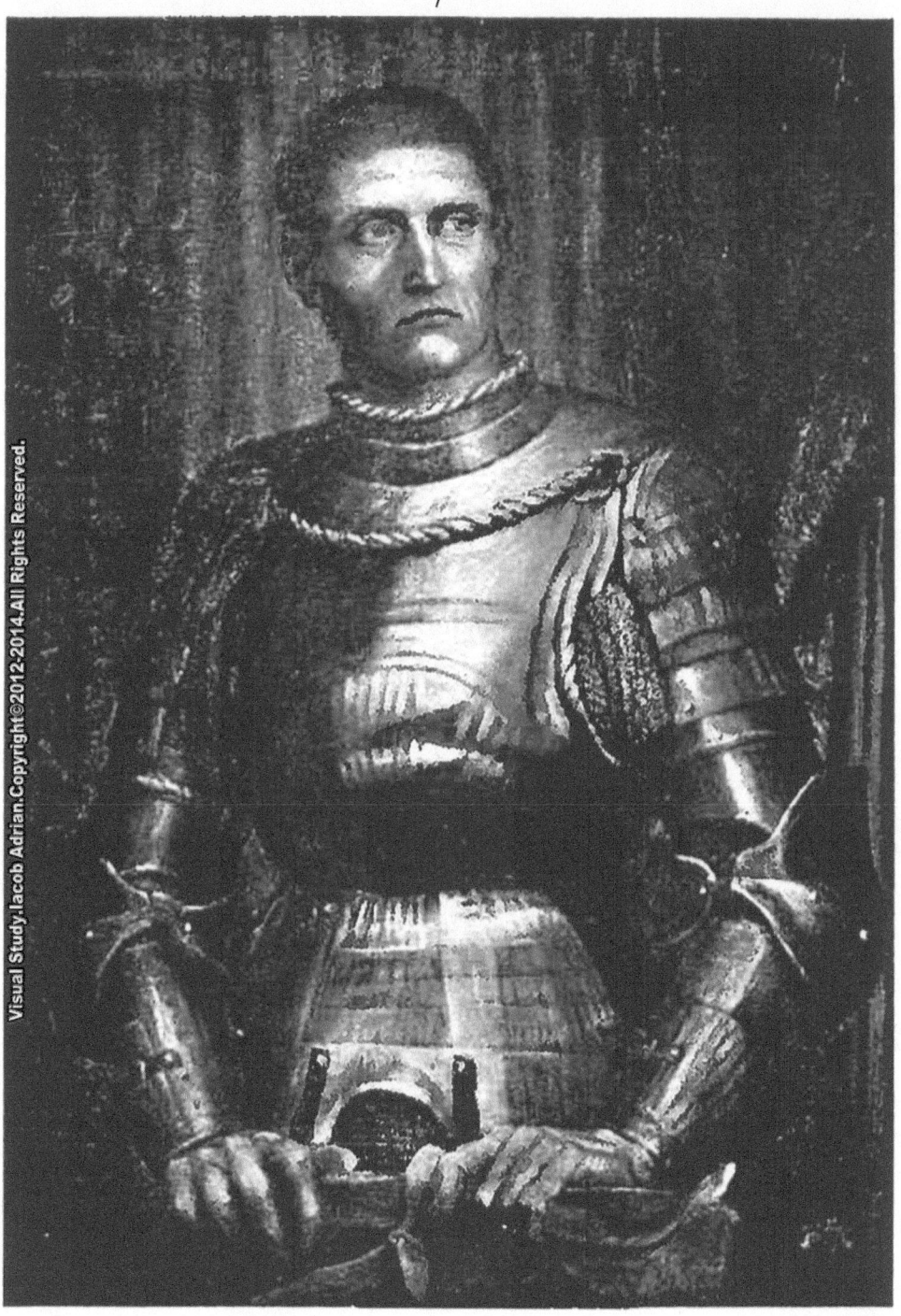

CONDOTTIERE
(Watts Gallery, Compton, Guildford)
F. Hollyer, Photo.

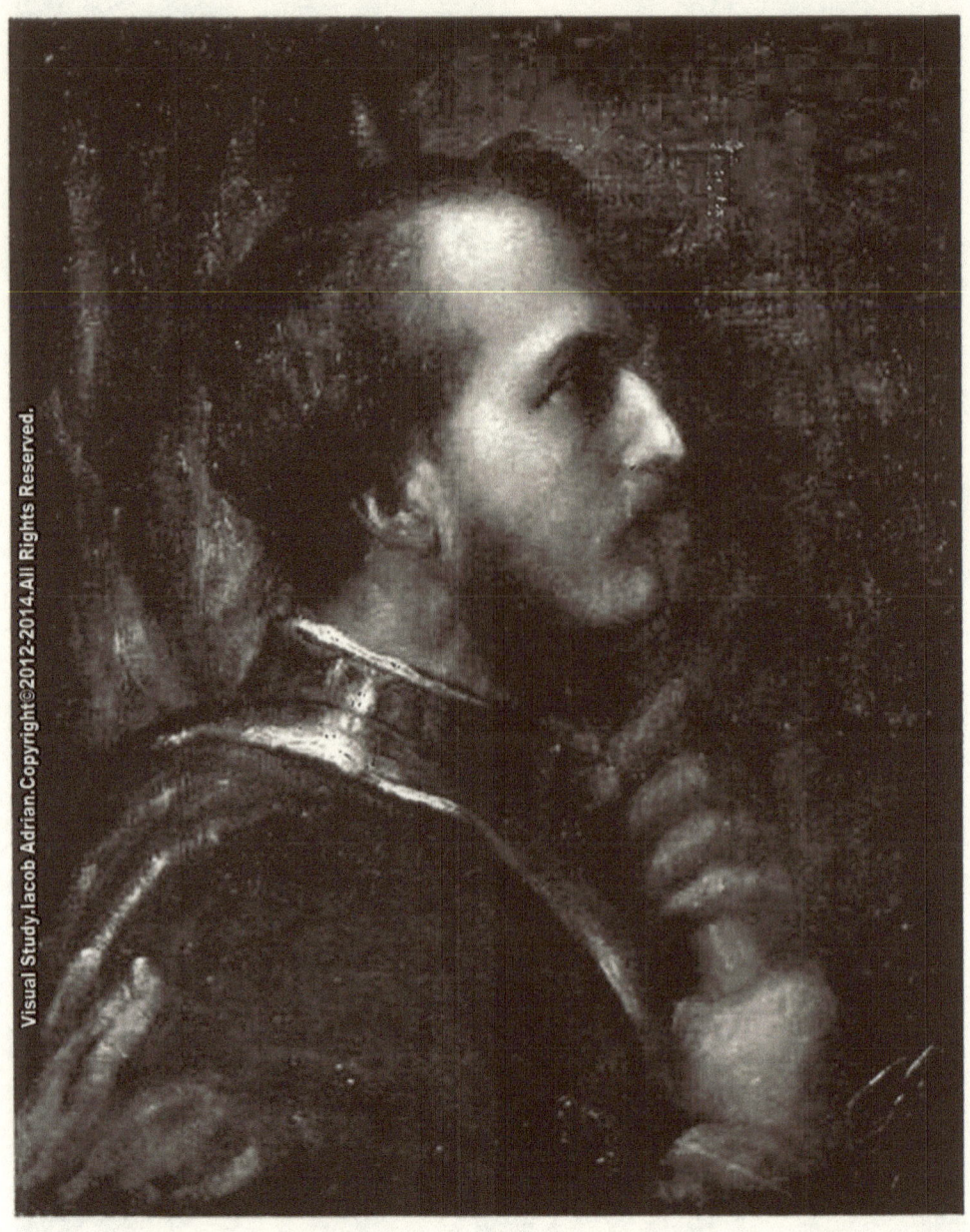

THE STANDARD-BEARER LE PORTE-ÉTENDARD
DER STANDARTENTRÄGER
(*Watts Gallery, Compton, Guildford*)
F. Hollyer, Photo.

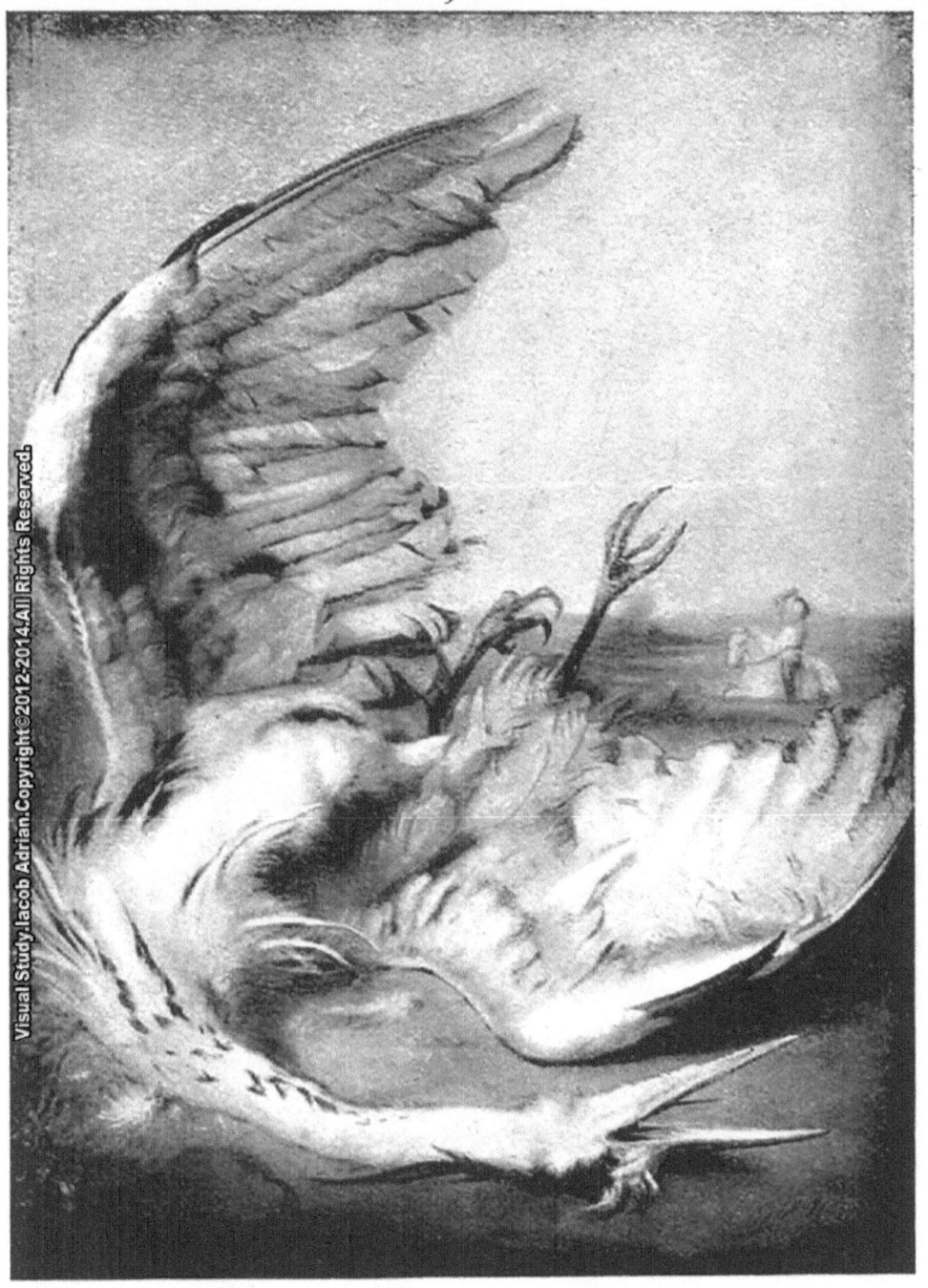

THE WOUNDED HERON LE HÉRON BLESSÉ
DER VERWUNDETE REIHER
(*Watts Gallery, Compton, Guildford*)
F. Hollyer, Photo.

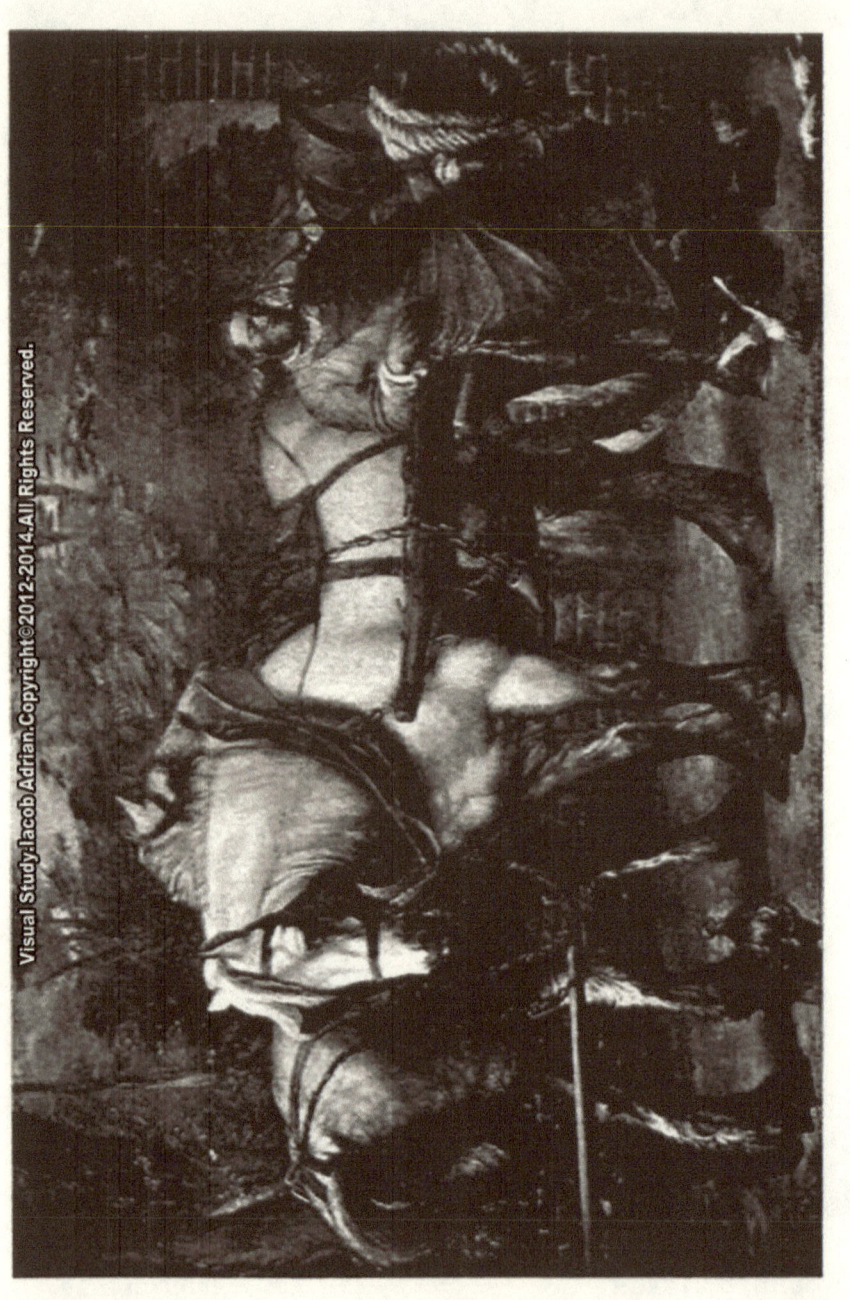

MIDDAY REST (DRAY HORSES) REPOS DU MIDI (CHEVAUX DE HAQUET)
MITTAGSRUHE (KARRENGÄULE) F. Hollyer, Photo.
(Tate Gallery, London)

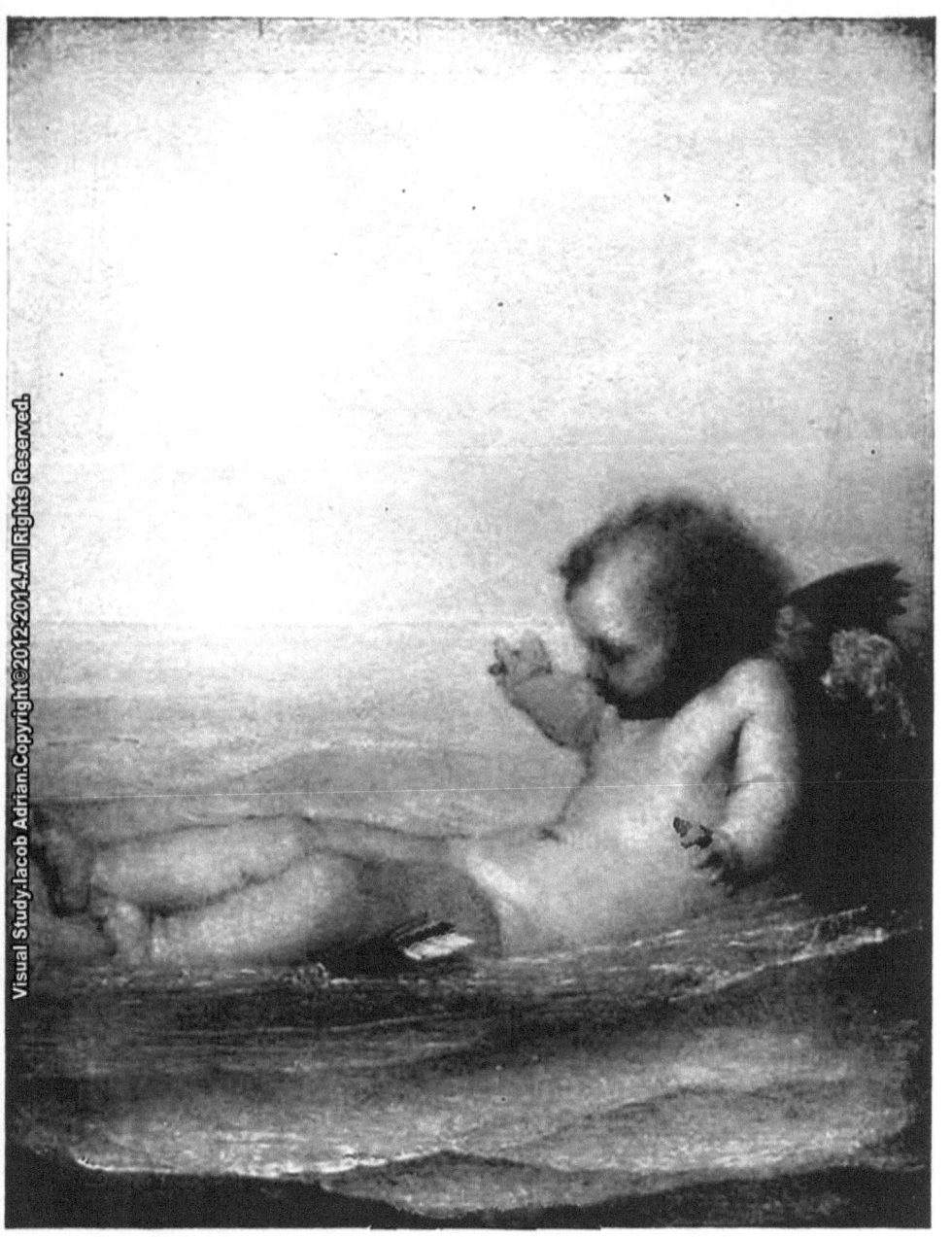

"I'm Afloat" "Ich bin flott" "Je flotte"
(Mr. James Smith, Liverpool)
F. Hollyer, Photo.

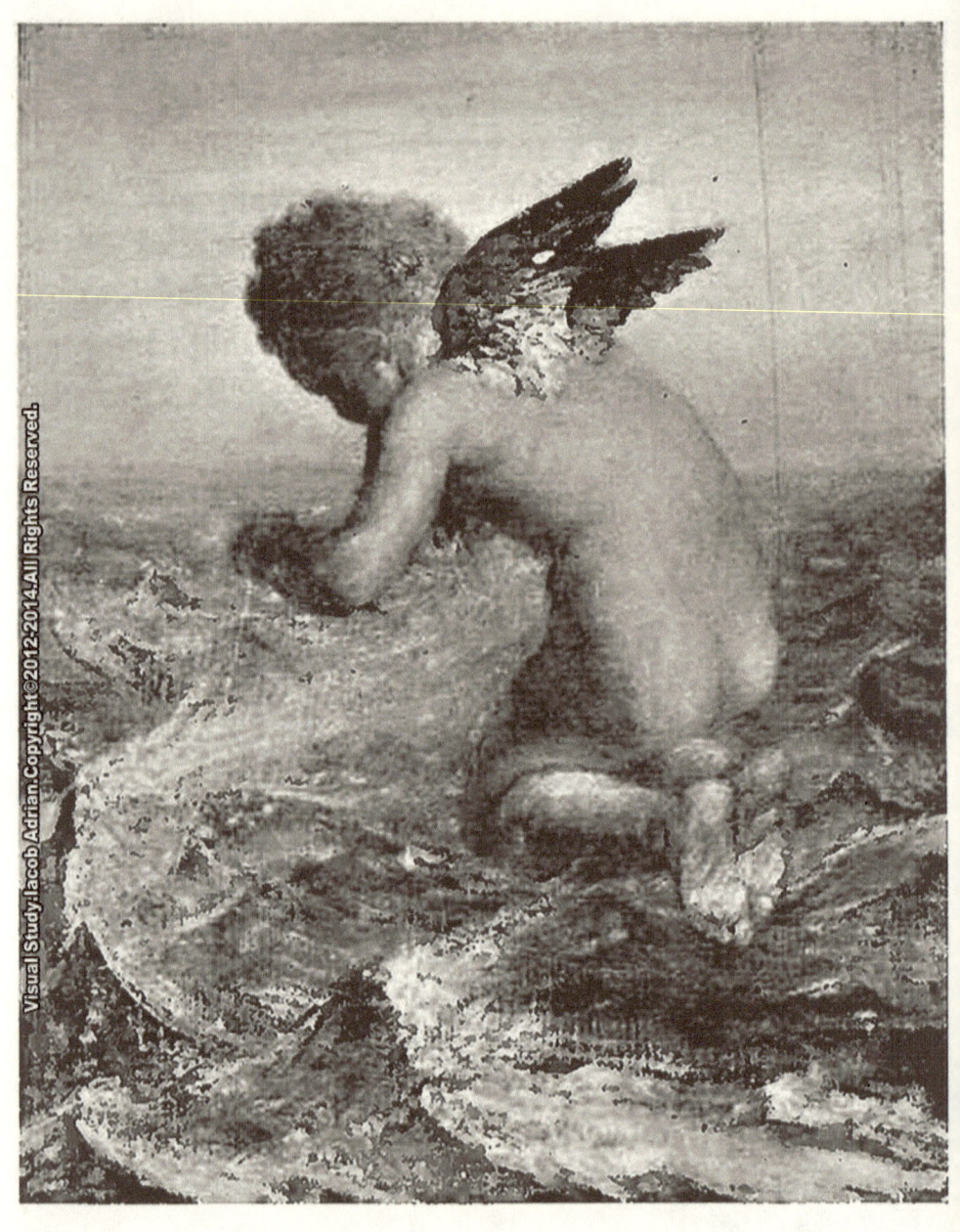

"Good Luck to your Fishing" "Bonne Chance dans votre Pêche"
"Glück auf Ihr Fischen"
(Lord Glenconner, London) F. Hollyer, Photo.

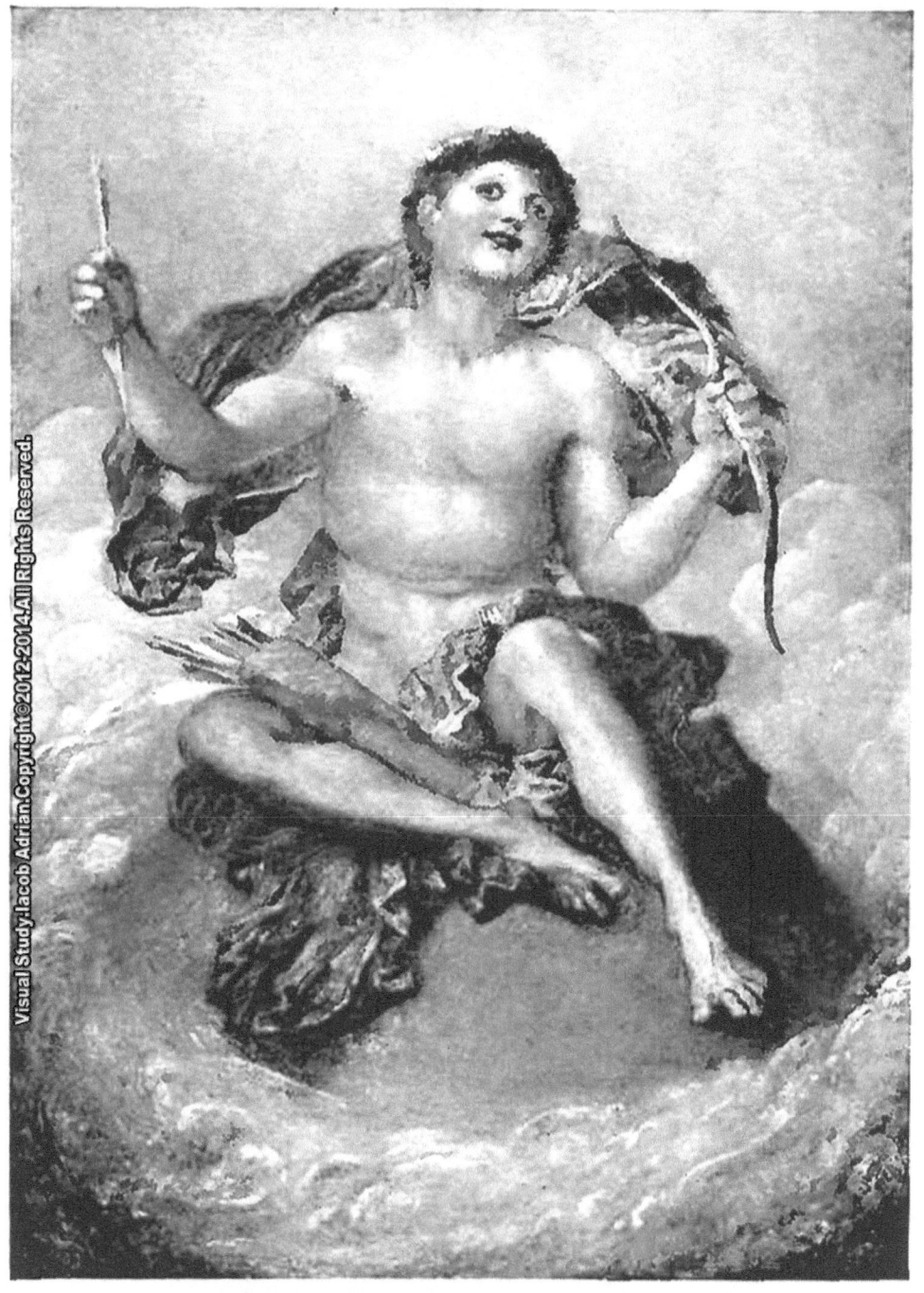

IDLE CHILD OF FANCY VAIN ENFANT DE LA FANTAISIE
EITLES KIND DER PHANTASIE
(*Watts Gallery, Compton, Guildford*)
F. Hollyer, Photo.

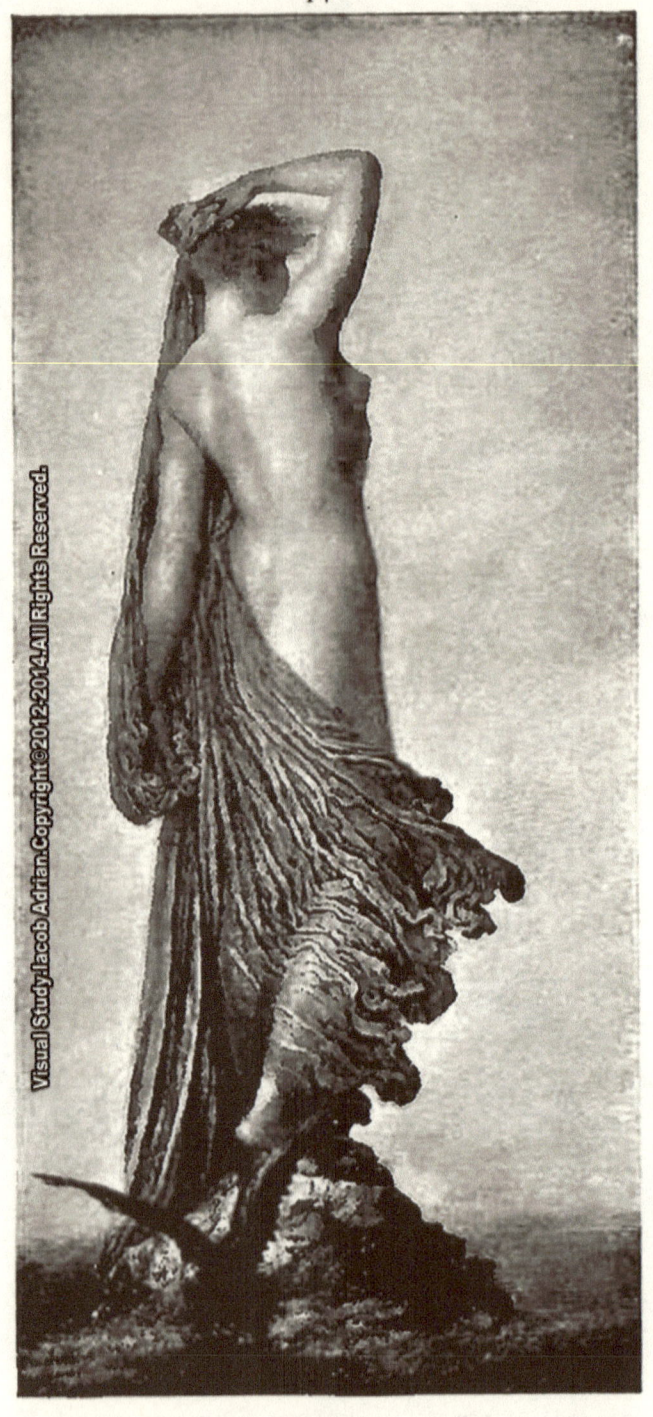

DAWN TAGESANBRUCH L'AURORE
(Recently in the possession of Messrs. Gooden & Fox, London)
F. Hollyer, Photo.

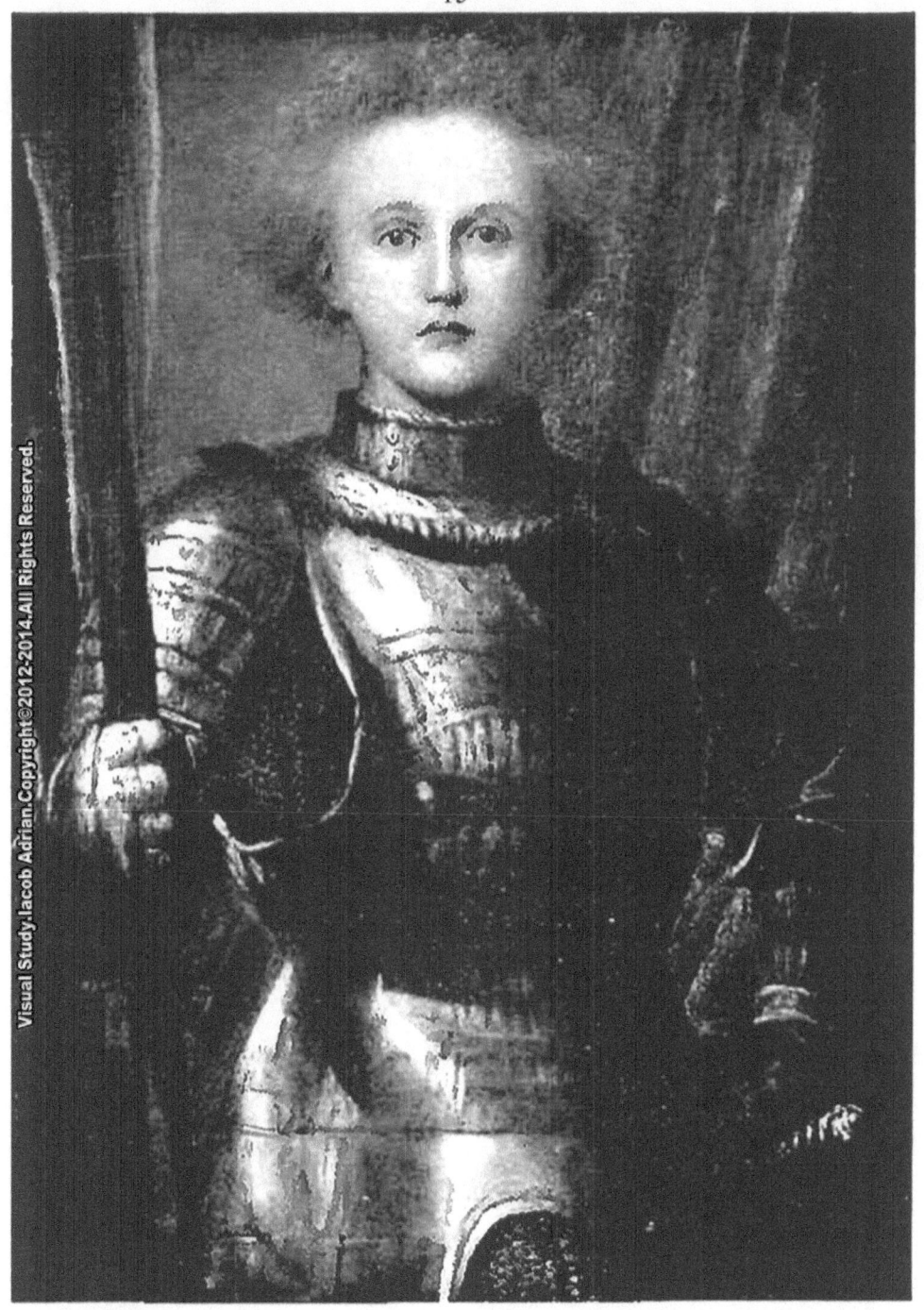

ASPIRATION DAS EMPORSTREBEN L'ASPIRATION
(*Mr. John T. Middlemore, Bromsgrove*)
F. Hollyer, Photo.

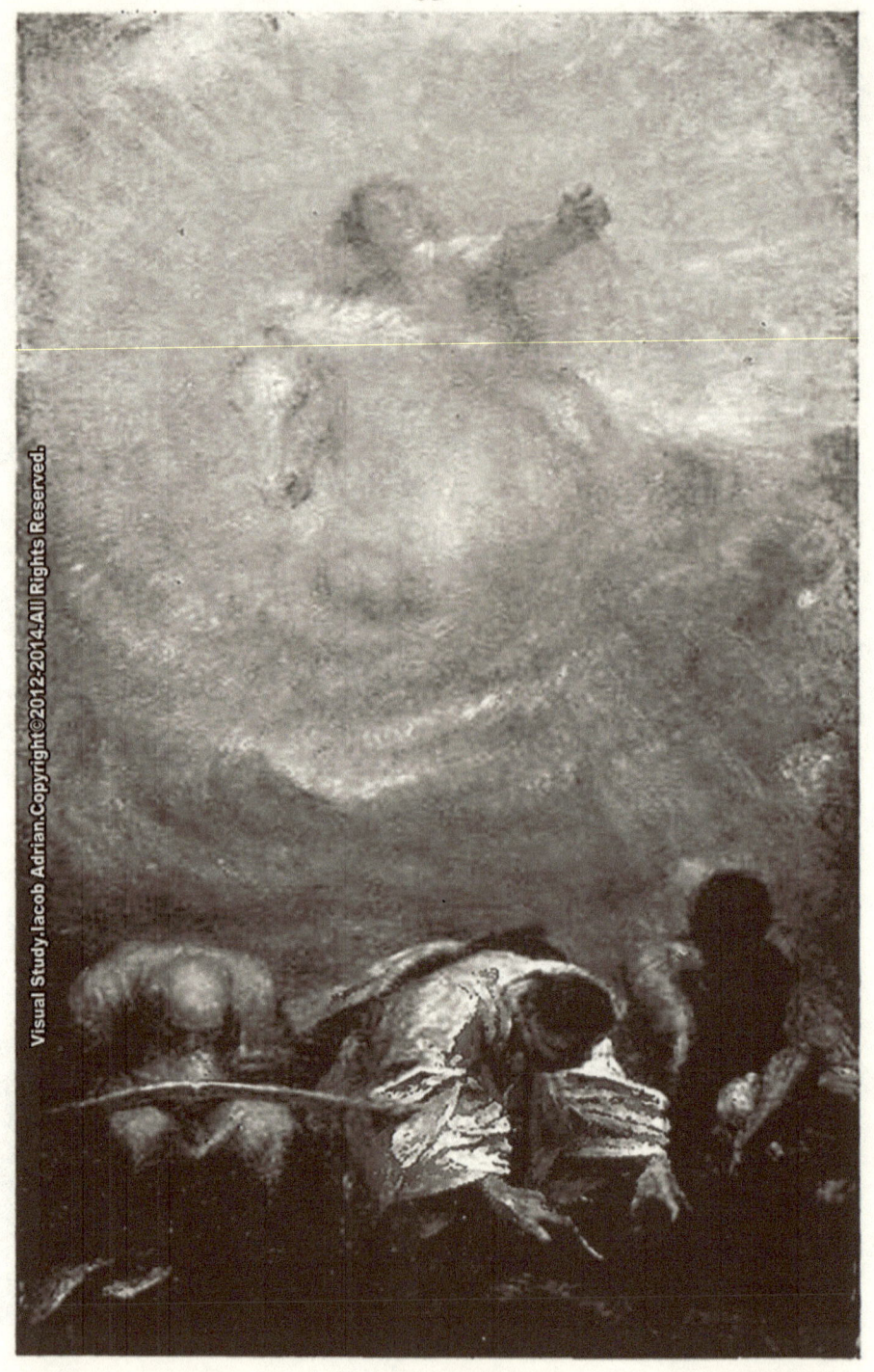

PROGRESS DER FORTSCHRITT LE PROGRÈS
(Watts Gallery, Compton, Guildford)
F. Hollyer, Photo.

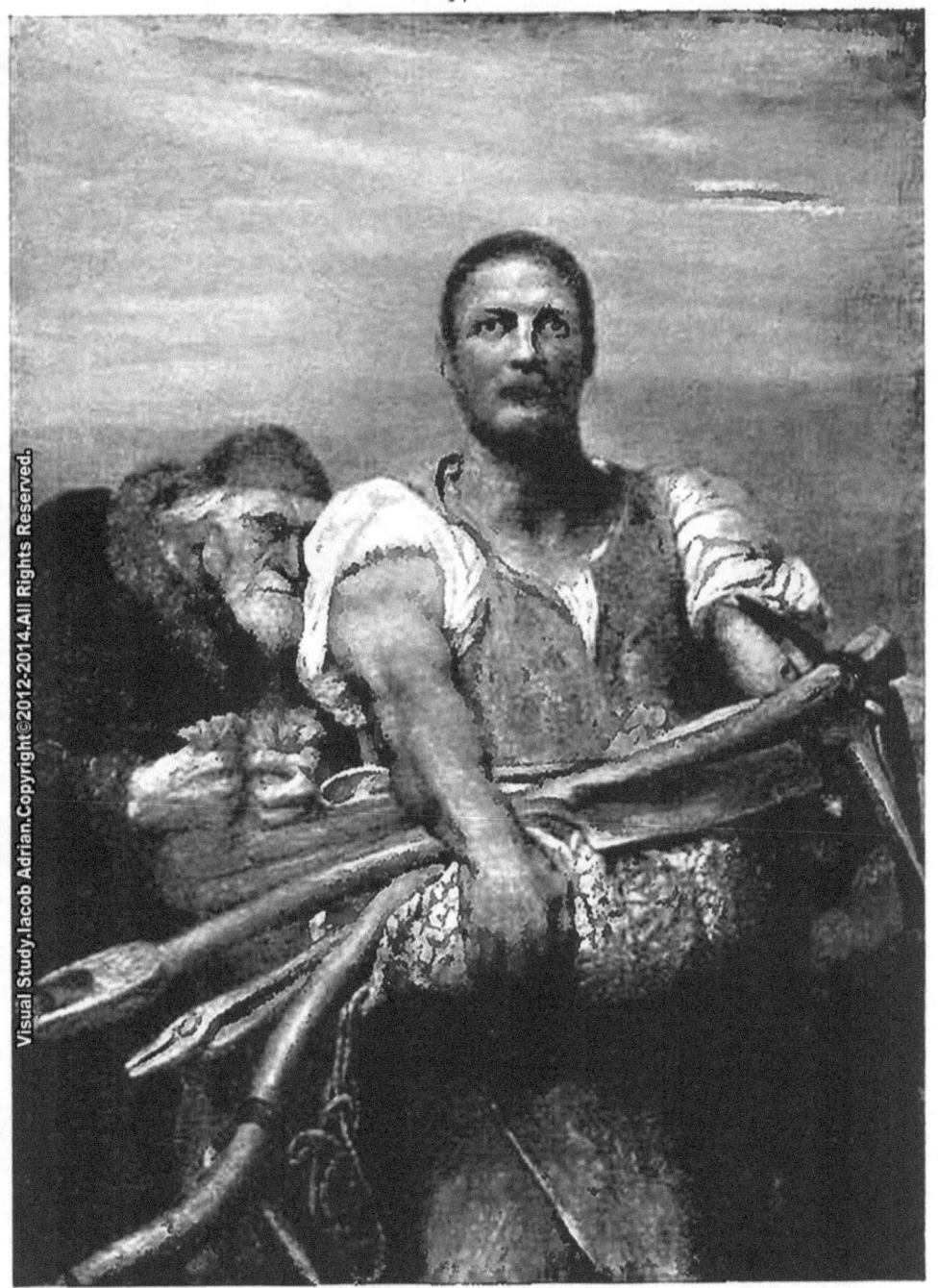

INDUSTRY AND GREED L'INDUSTRIE ET L'AVARICE
GEWERBEFLEISS UND HABGIER
(*Watts Gallery, Compton, Guildford*)
F. Hollyer, Photo.

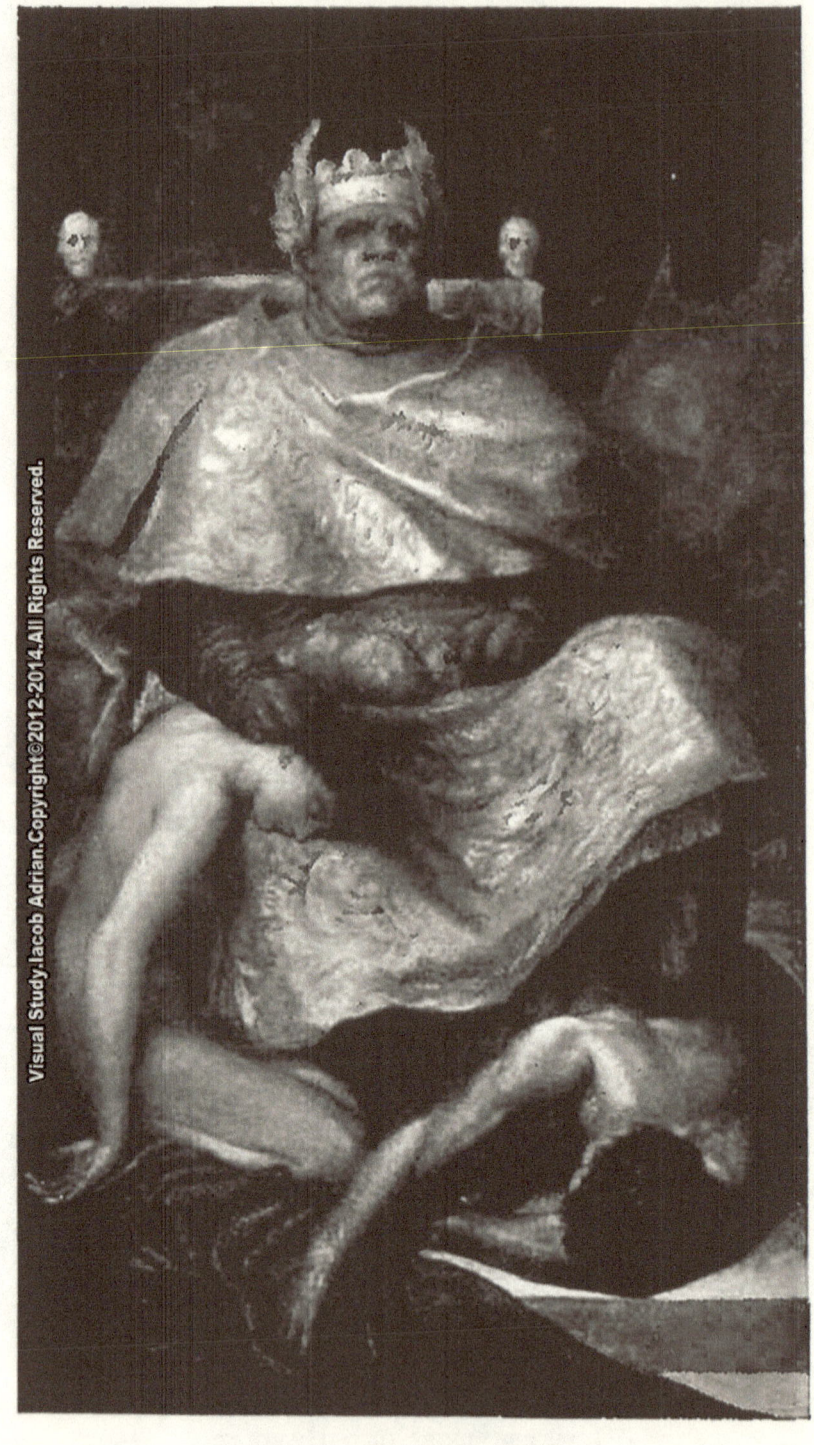

MAMMON
(*Tate Gallery, London*)
F. Hollyer, Photo.

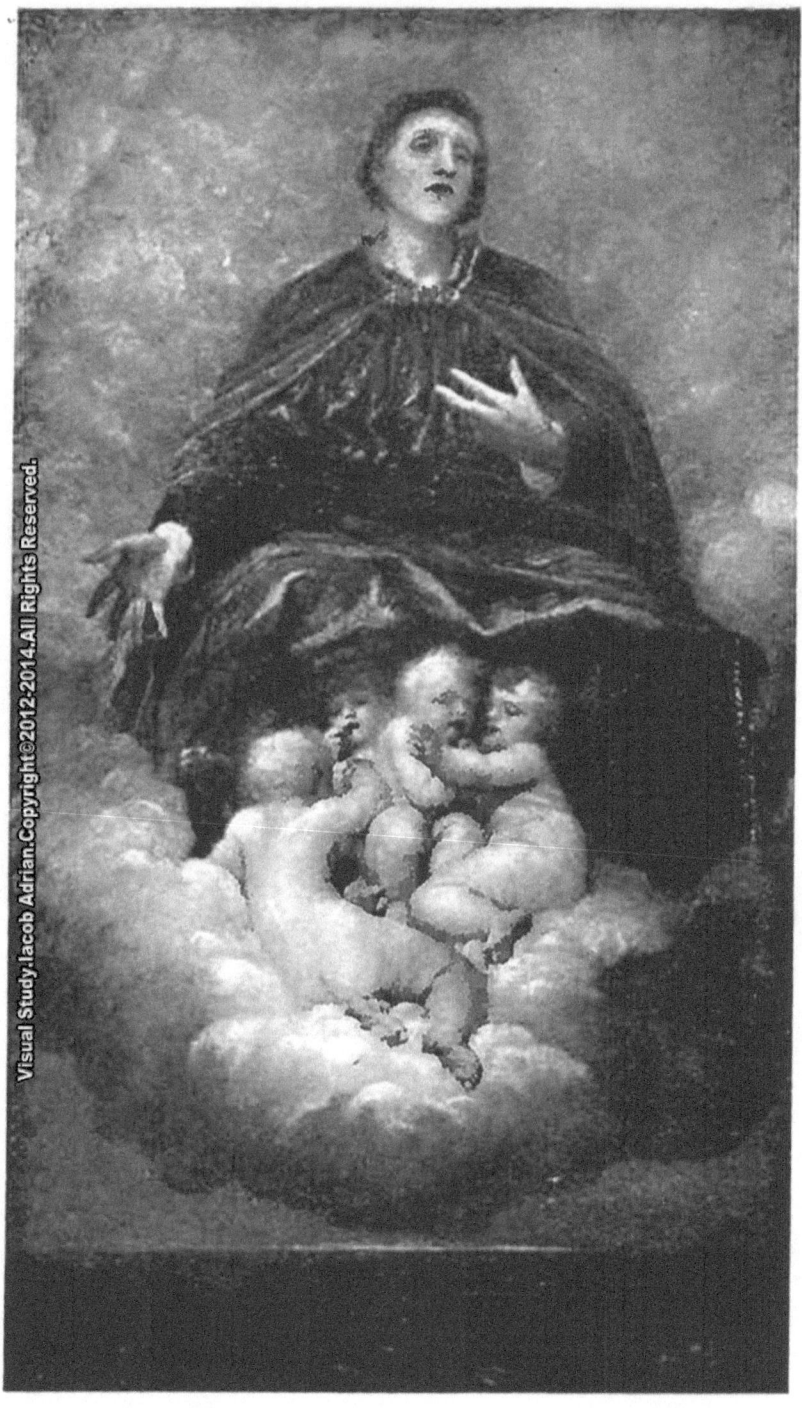

THE SPIRIT OF CHRISTIANITY L'ESPRIT DU CHRISTIANISME
DER GEIST DES CHRISTENTUMS
(Tate Gallery, London) F. Hollyer, Photo.

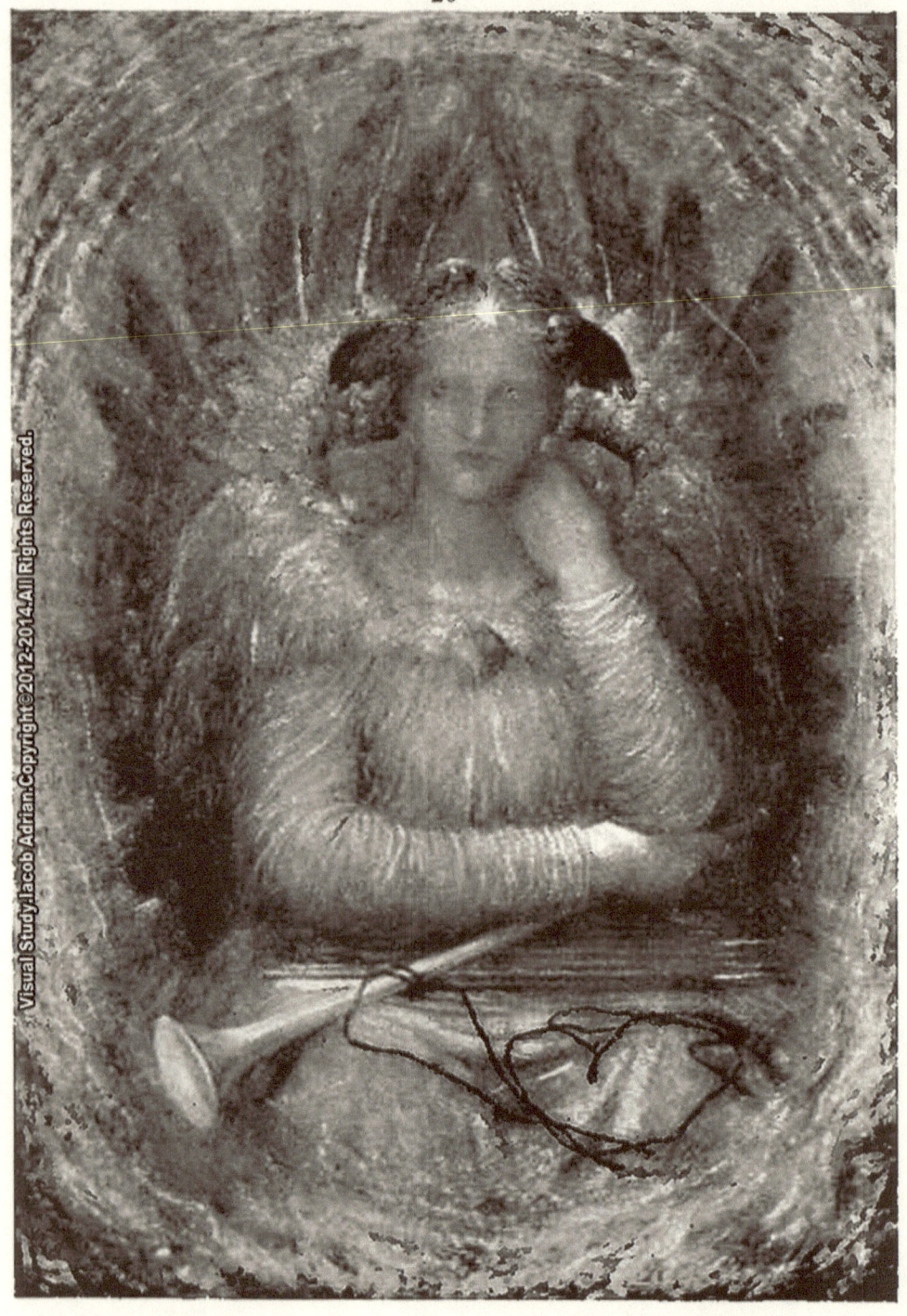

The Dweller in the Innermost — L'Habitant des Régions Intérieures
Der Bewohner im Innersten
(Tate Gallery, London) F. Hollyer, Photo.

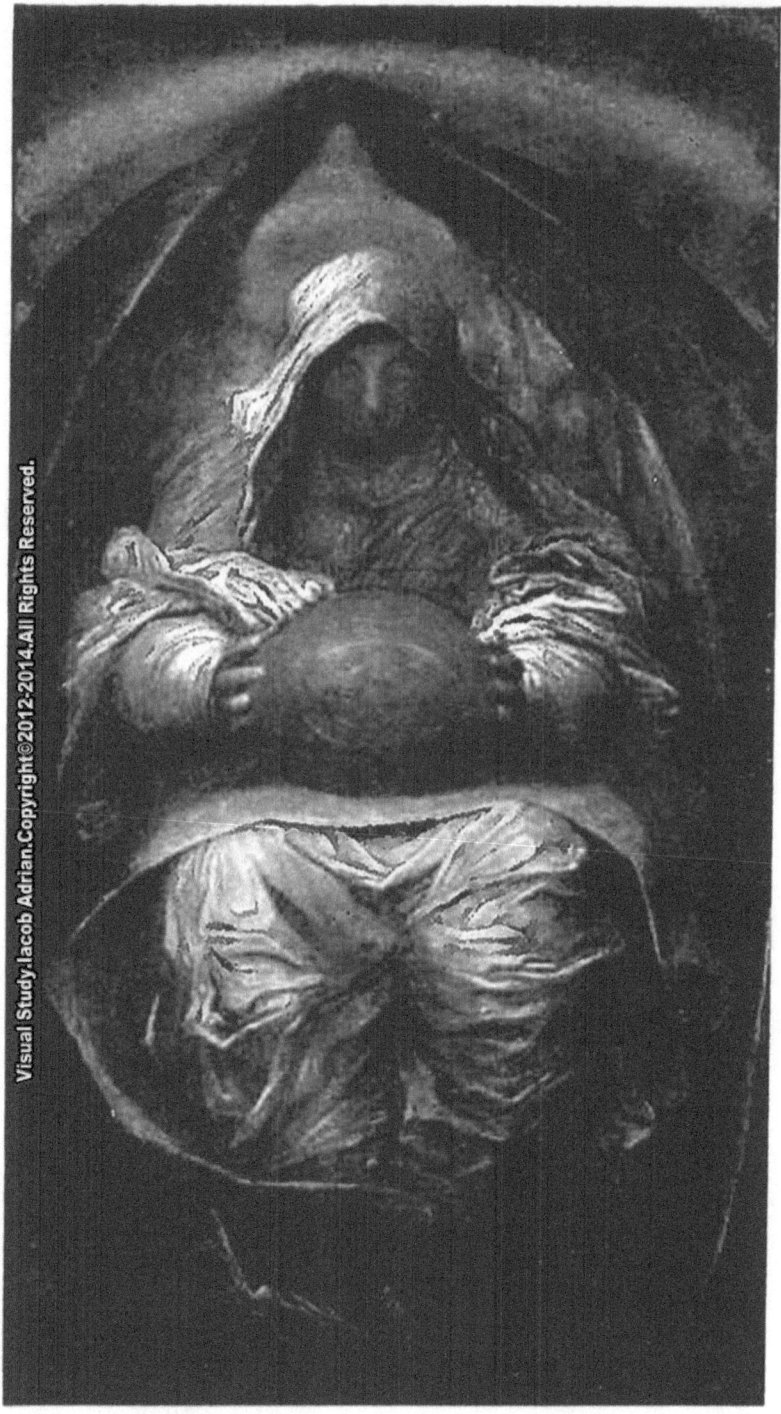

THE ALL PERVADING QUI SE RÉPAND DANS TOUT
DER ALLDURCHDRINGENDE
(*Tate Gallery, London*) *F. Hollyer, Photo.*

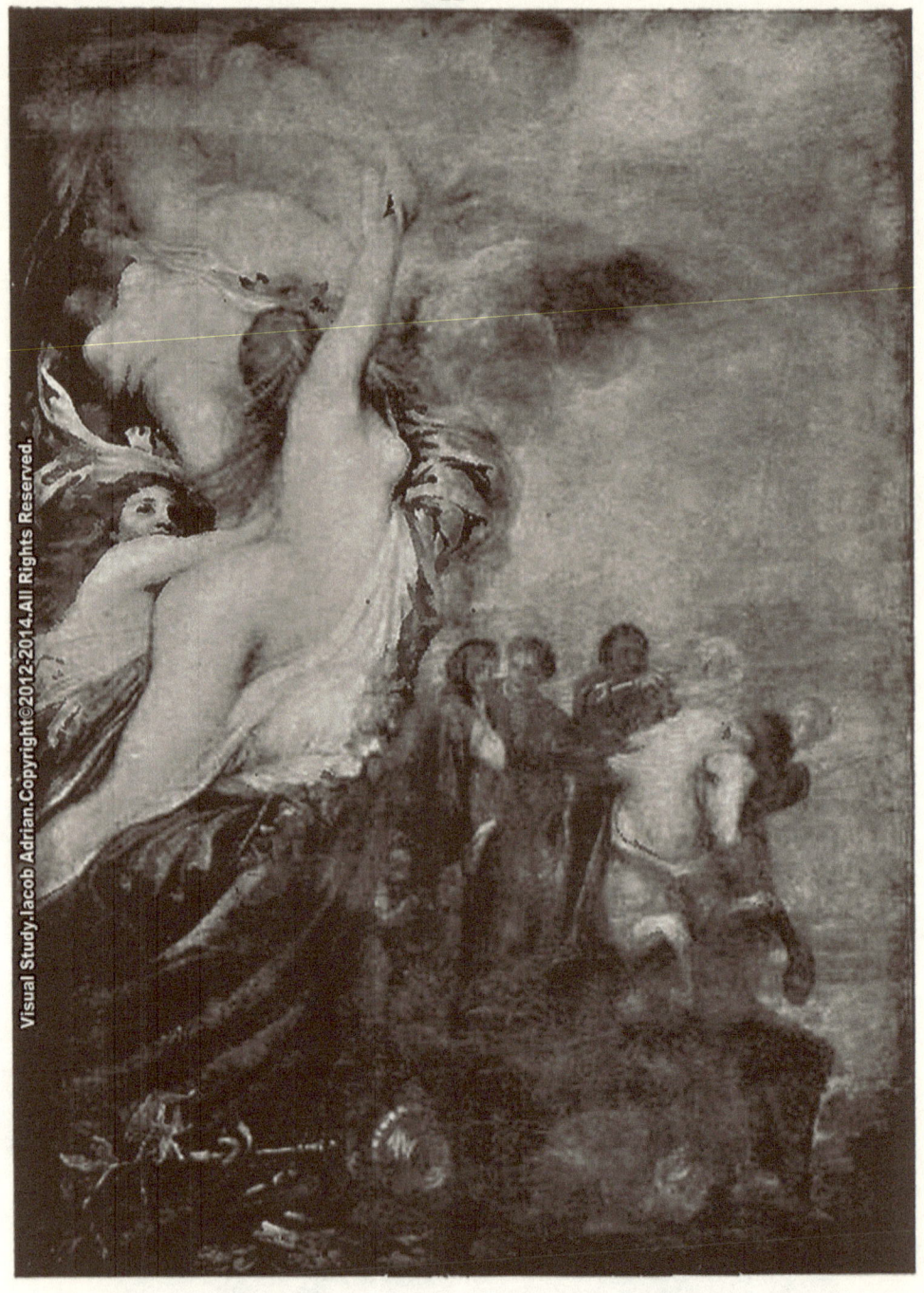

Life's Illusions Les Illusions de la Vie
Die Illusionen des Lebens
(Tate Gallery, London)
F. Hollyer, Photo.

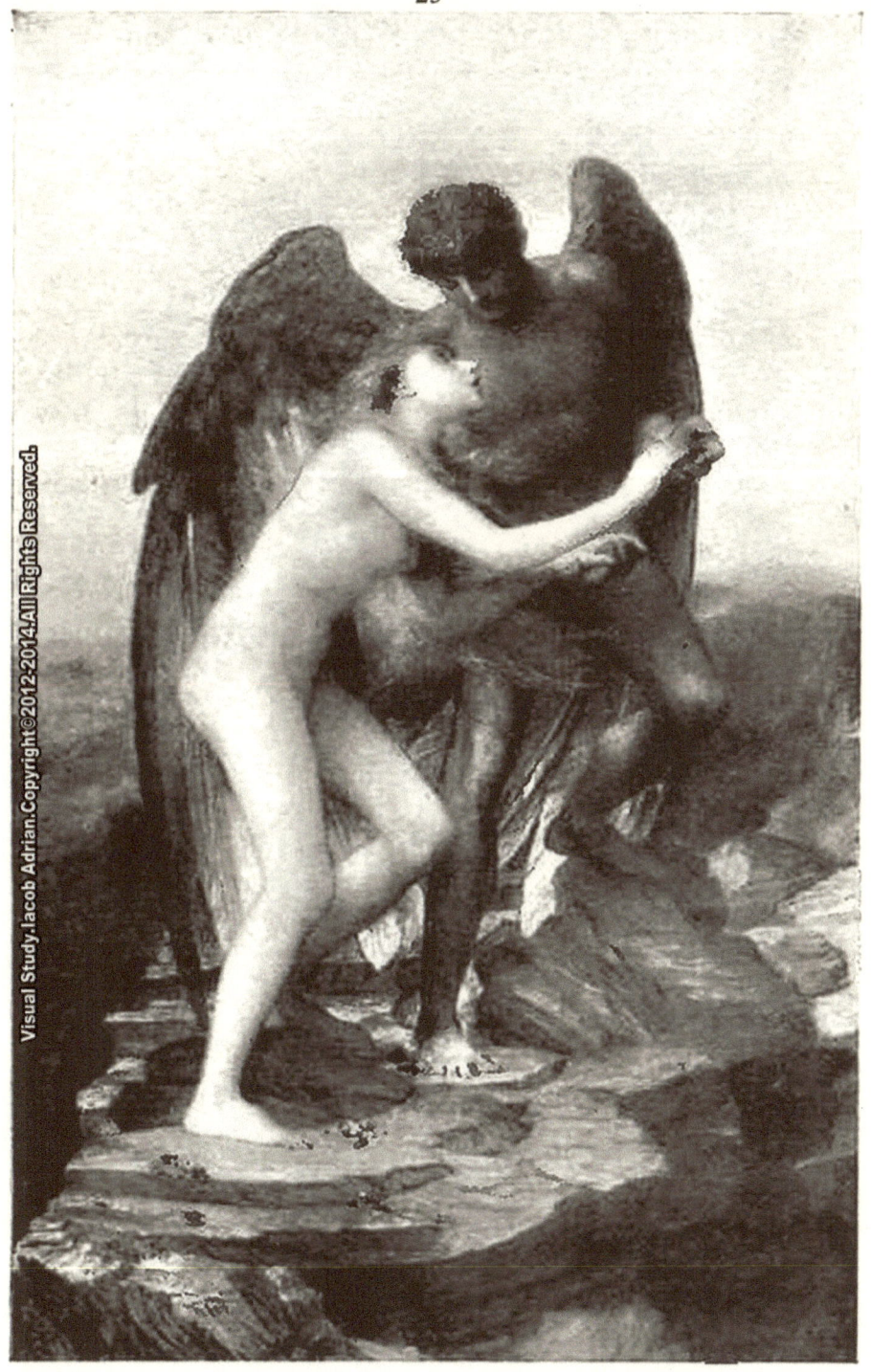

LOVE AND LIFE L'AMOUR ET LA VIE
LIEBE UND LEBEN
(Tate Gallery, London) F. Hollyer, Photo.

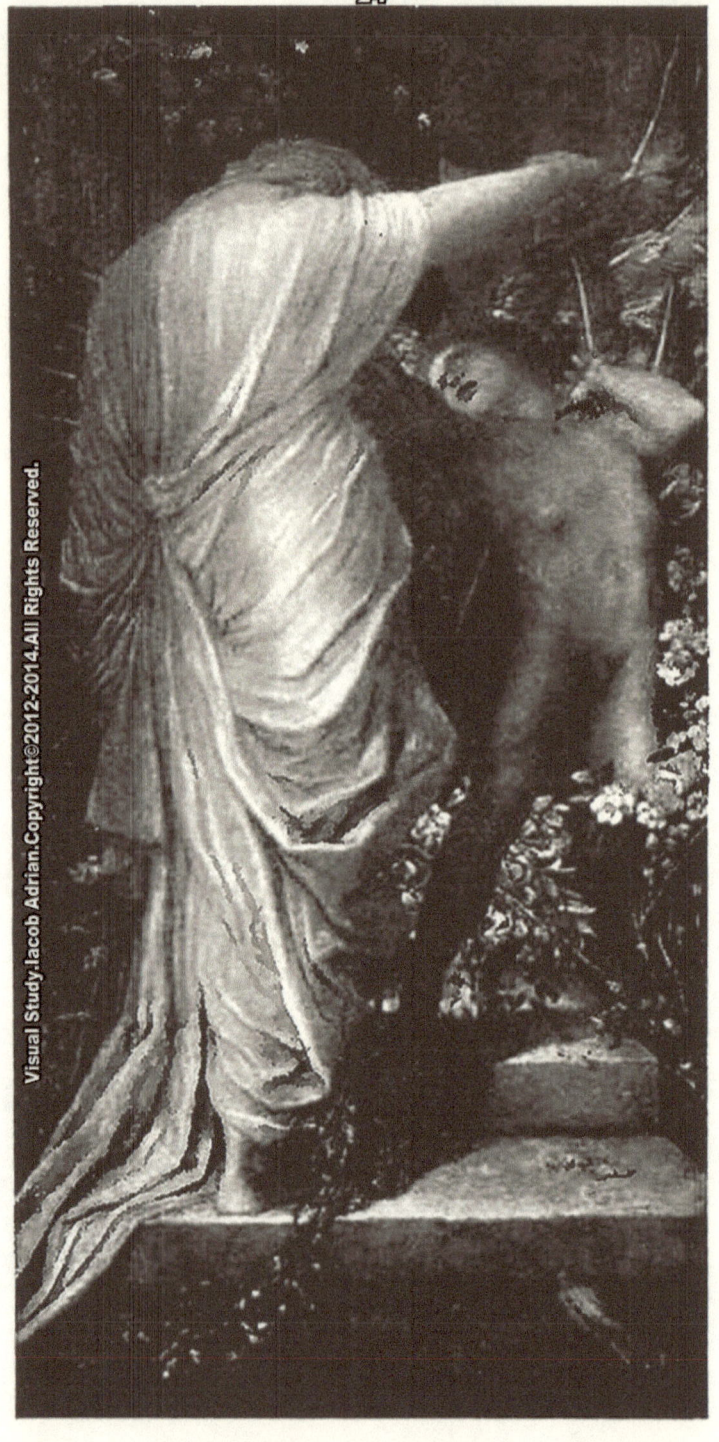

Love and Death L'Amour et la Mort
Liebe und Tod
(Tate Gallery, London) F. Hollyer, Photo.

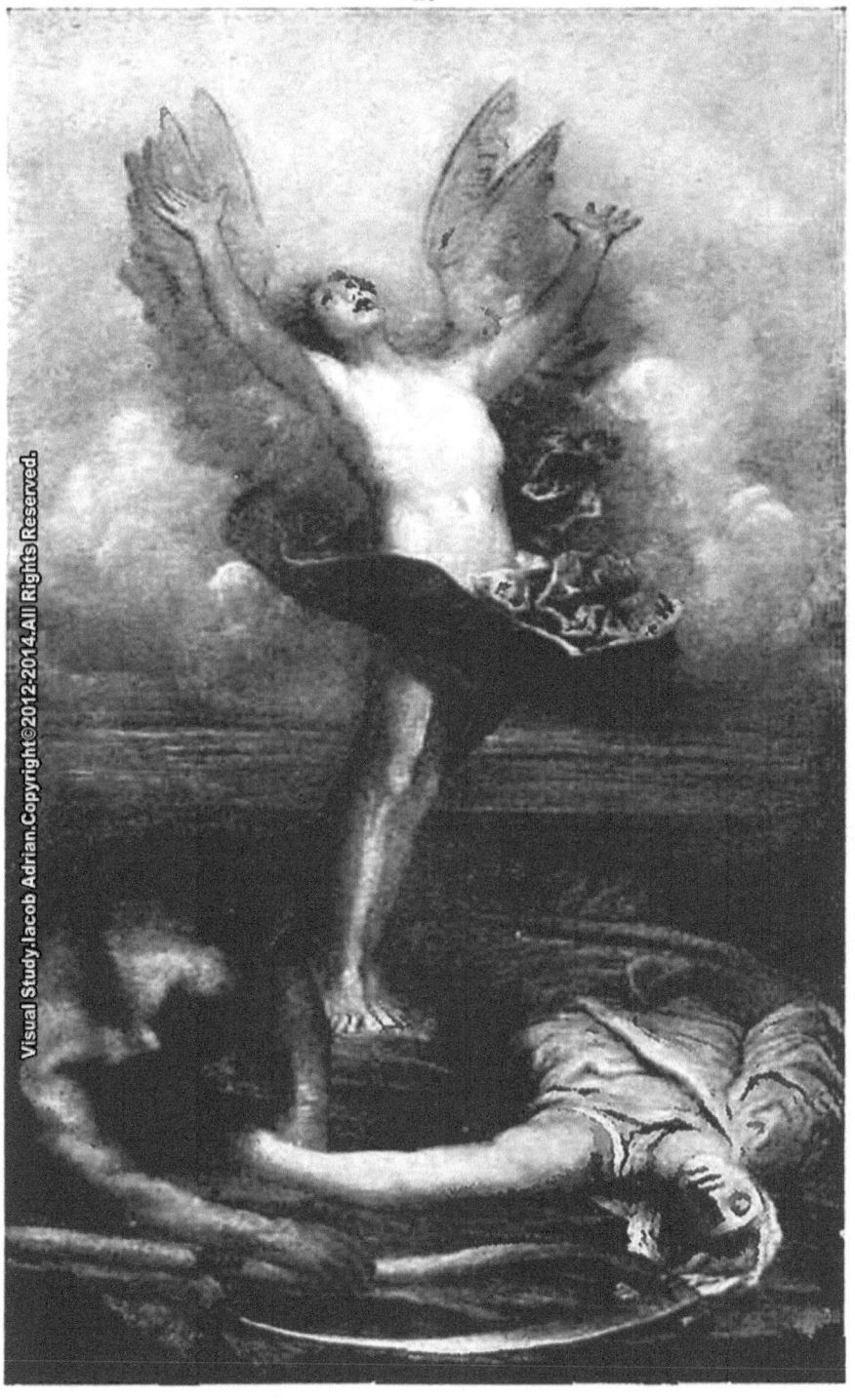

Love triumphant — L'Amour triomphant
Triumphierende Liebe
(Tate Gallery, London) F. Hollyer, Photo.

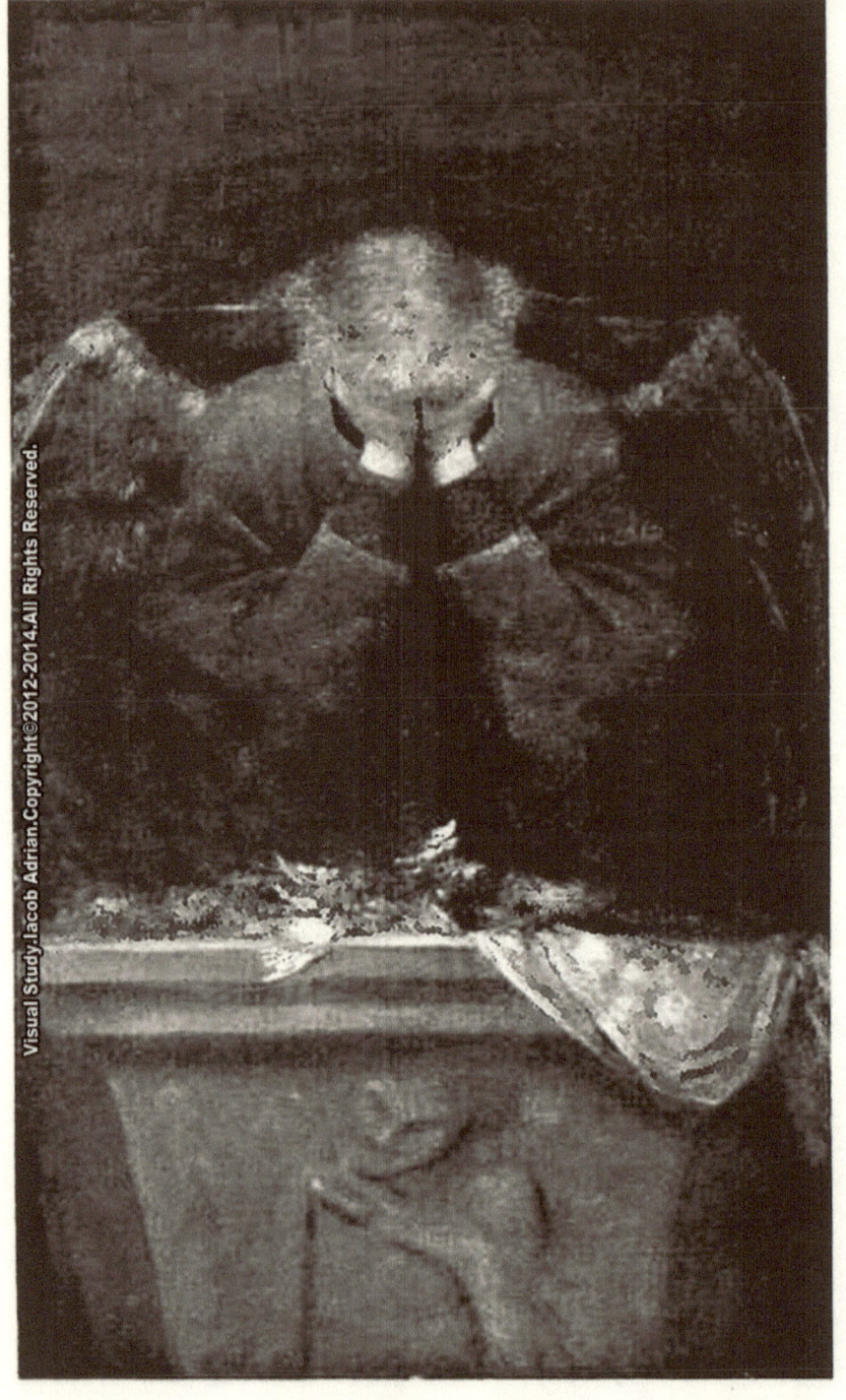

THE SHUDDERING ANGEL. L'ANGE QUI FRISSONNE
DER SCHAUDERNDE ENGEL.
(*Watts Gallery, Compton, Guildford*) *F. Hollyer, Photo.*

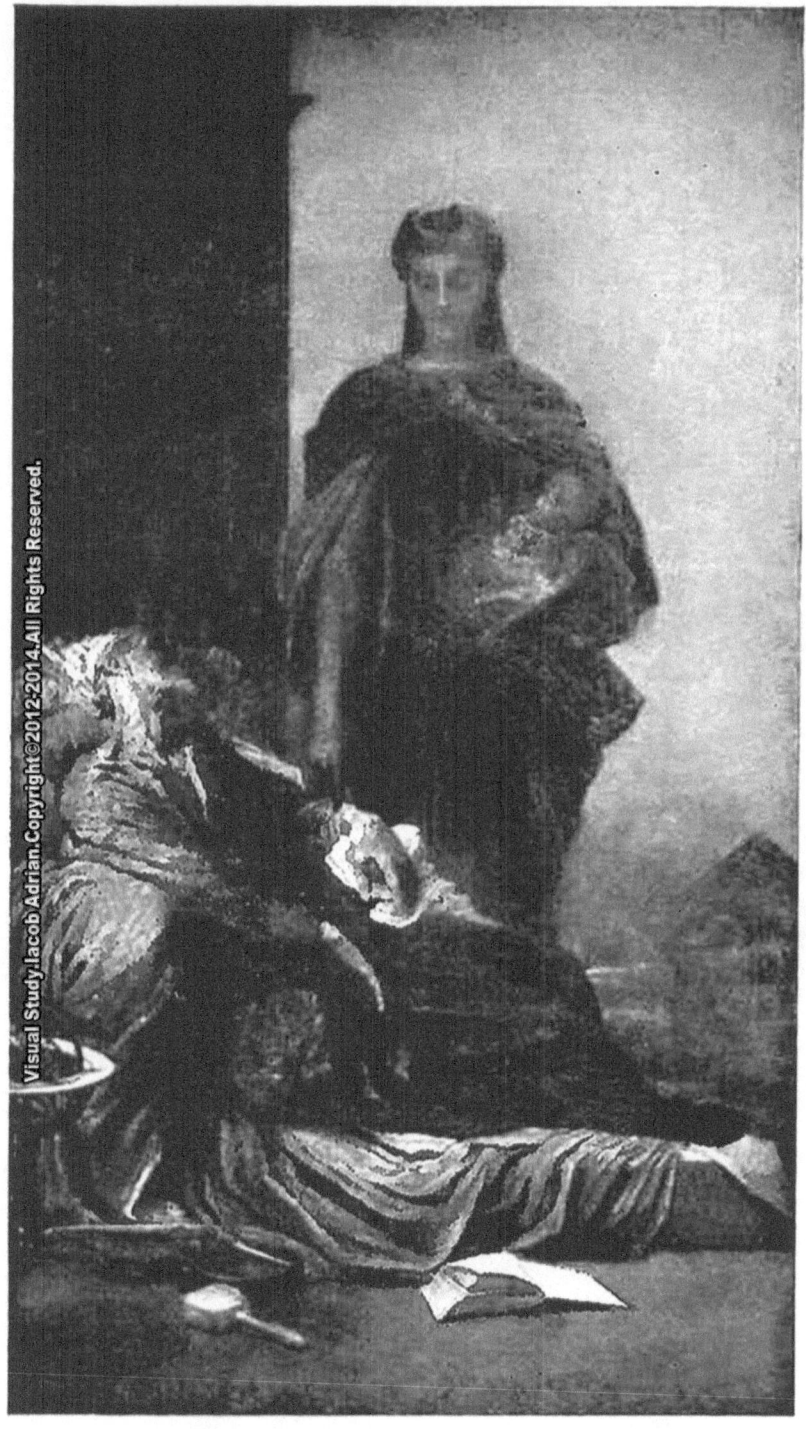

THE MESSENGER LE MESSAGER
DER ABGESANDTE
(Tate Gallery, London) F. Hollyer, Photo.

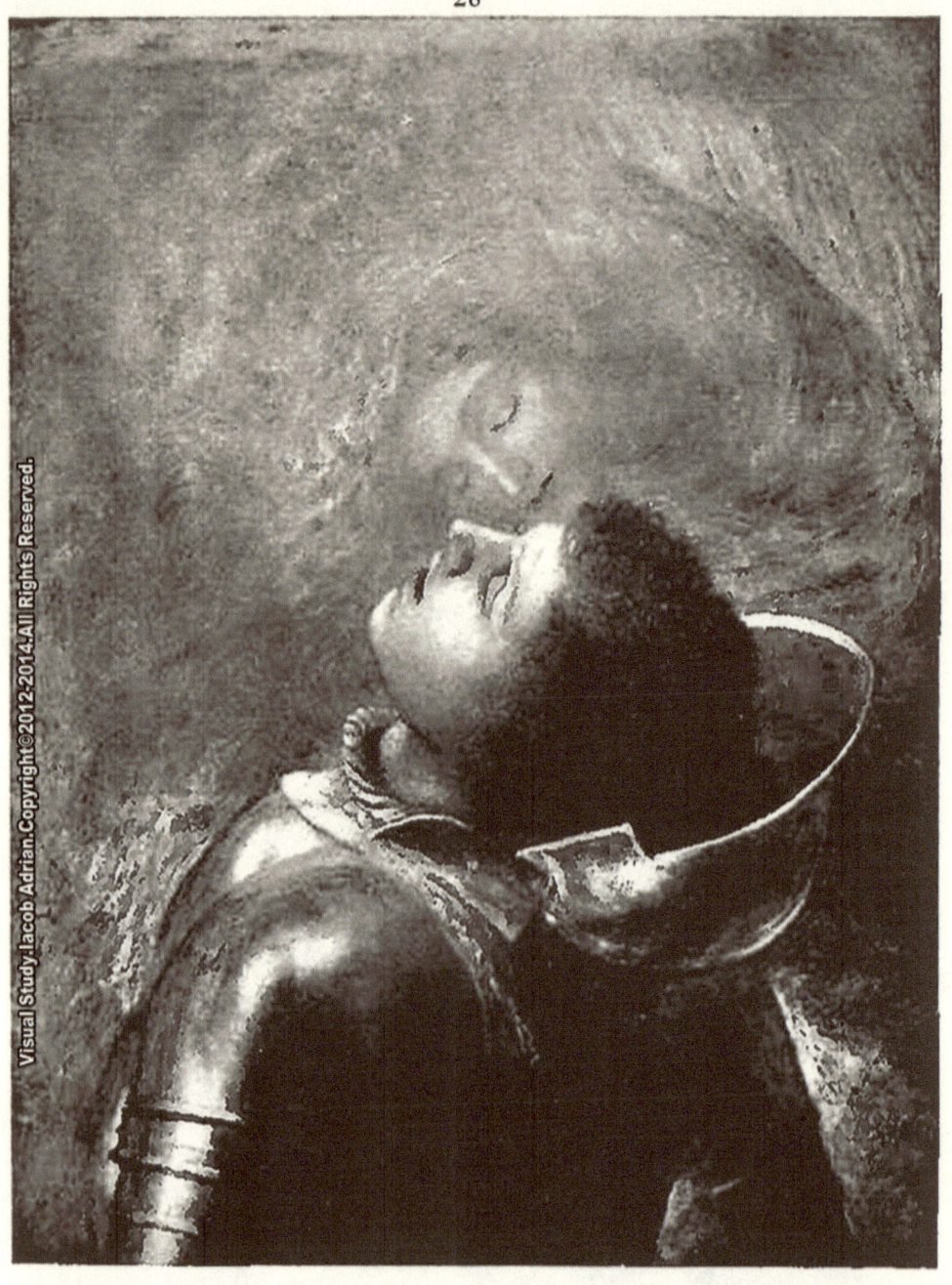

THE HAPPY WARRIOR LE GUERRIER HEUREUX
(New Pinacotheca, Munich) (Nouvelle Pinacothèque, Munich)
DER GLÜCKLICHE KRIEGER
(Neue Pinakothek, München)
F. Hollyer, Photo.

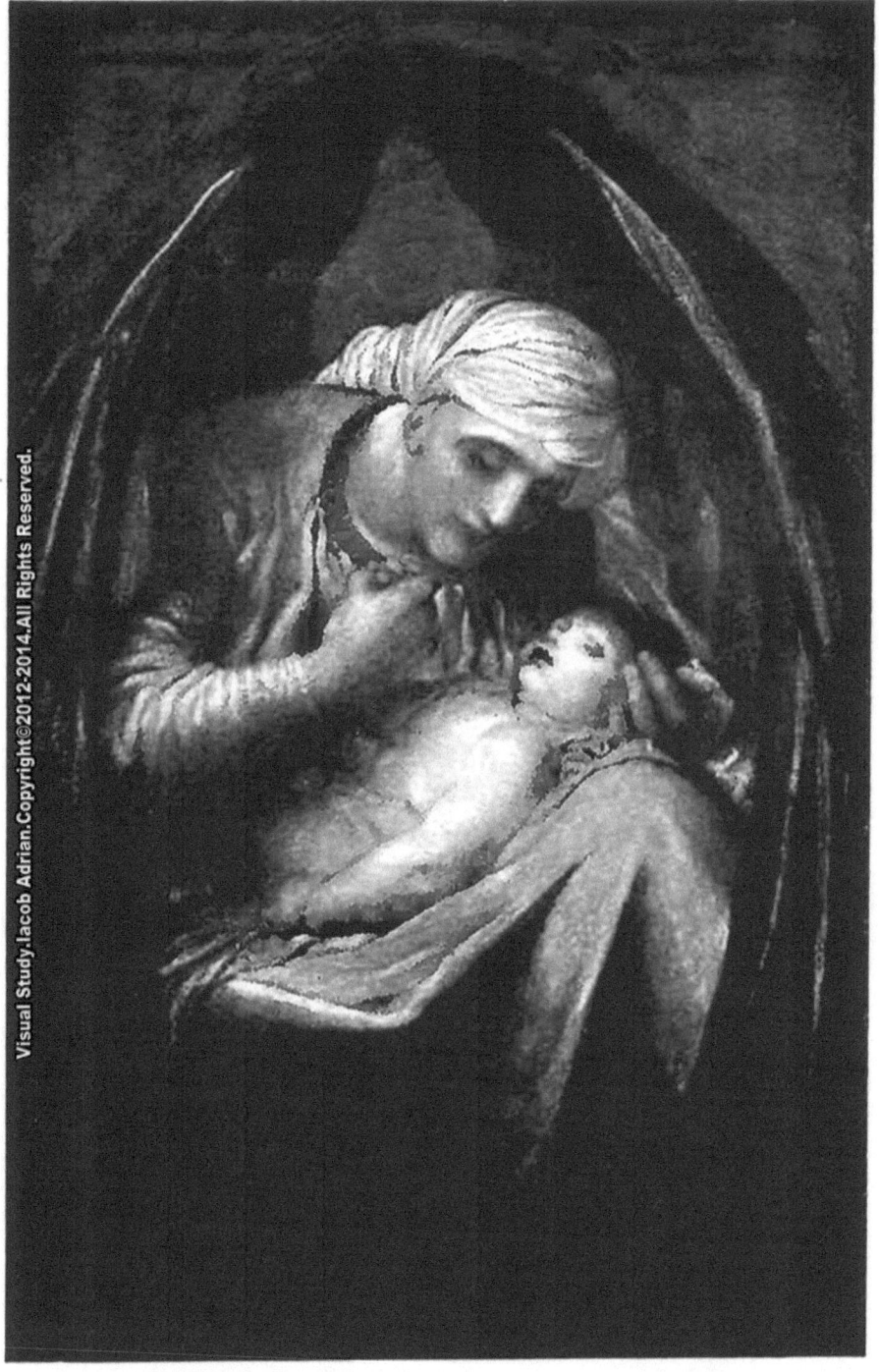

DEATH CROWNING INNOCENCE LA MORT COURONNANT L'INNOCENCE
DER TOD KRÖNT DIE UNSCHULD
(*Tate Gallery, London*) *F. Hollyer, Photo.*

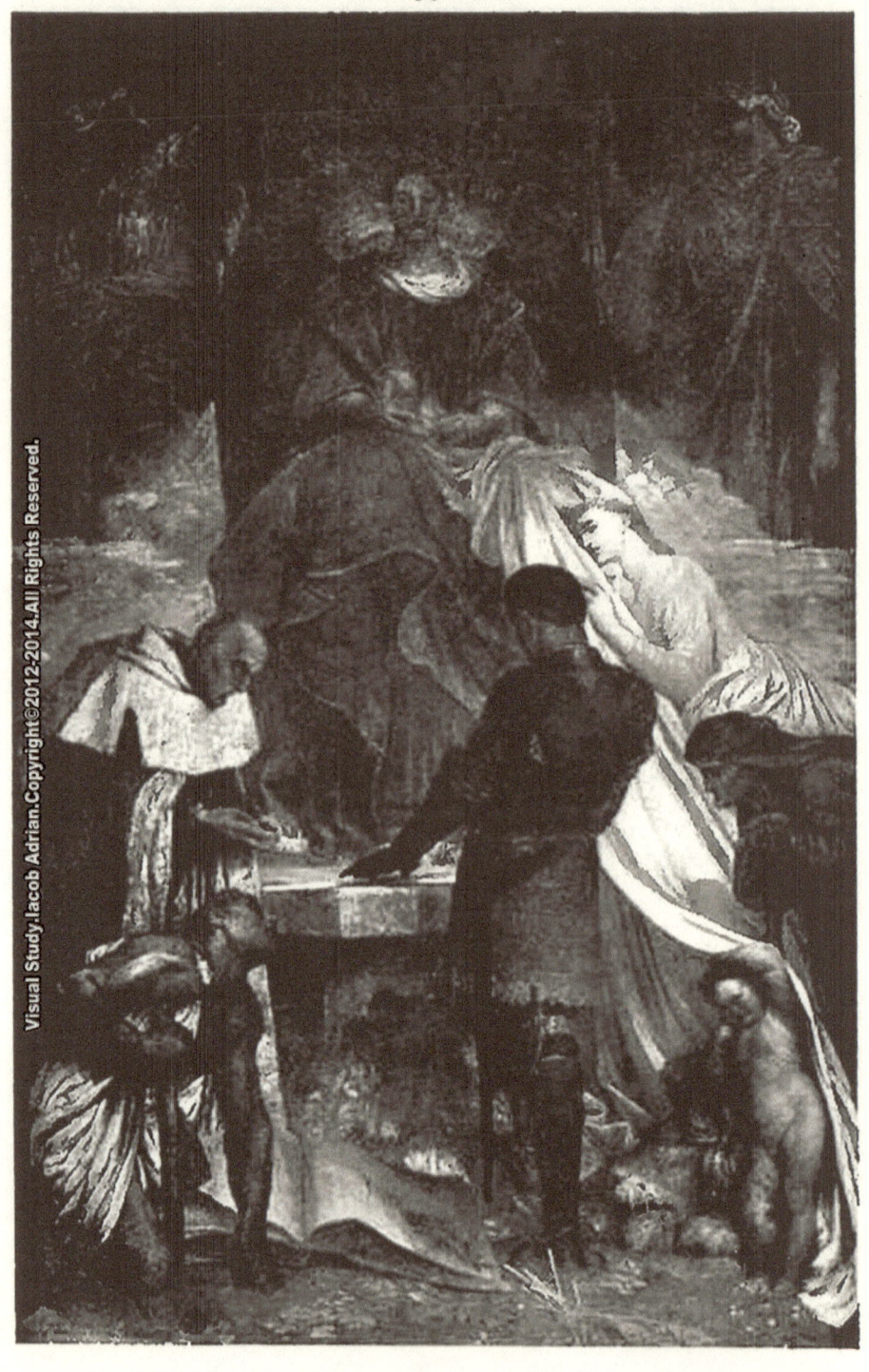

THE COURT OF DEATH LA COUR DE LA MORT
DER HOF DES TODES
(*Tate Gallery, London*) *F. Hollyer, Photo.*

"Sic Transit Gloria Mundi"
(Tate Gallery, London)
F. Hollyer, Photo.

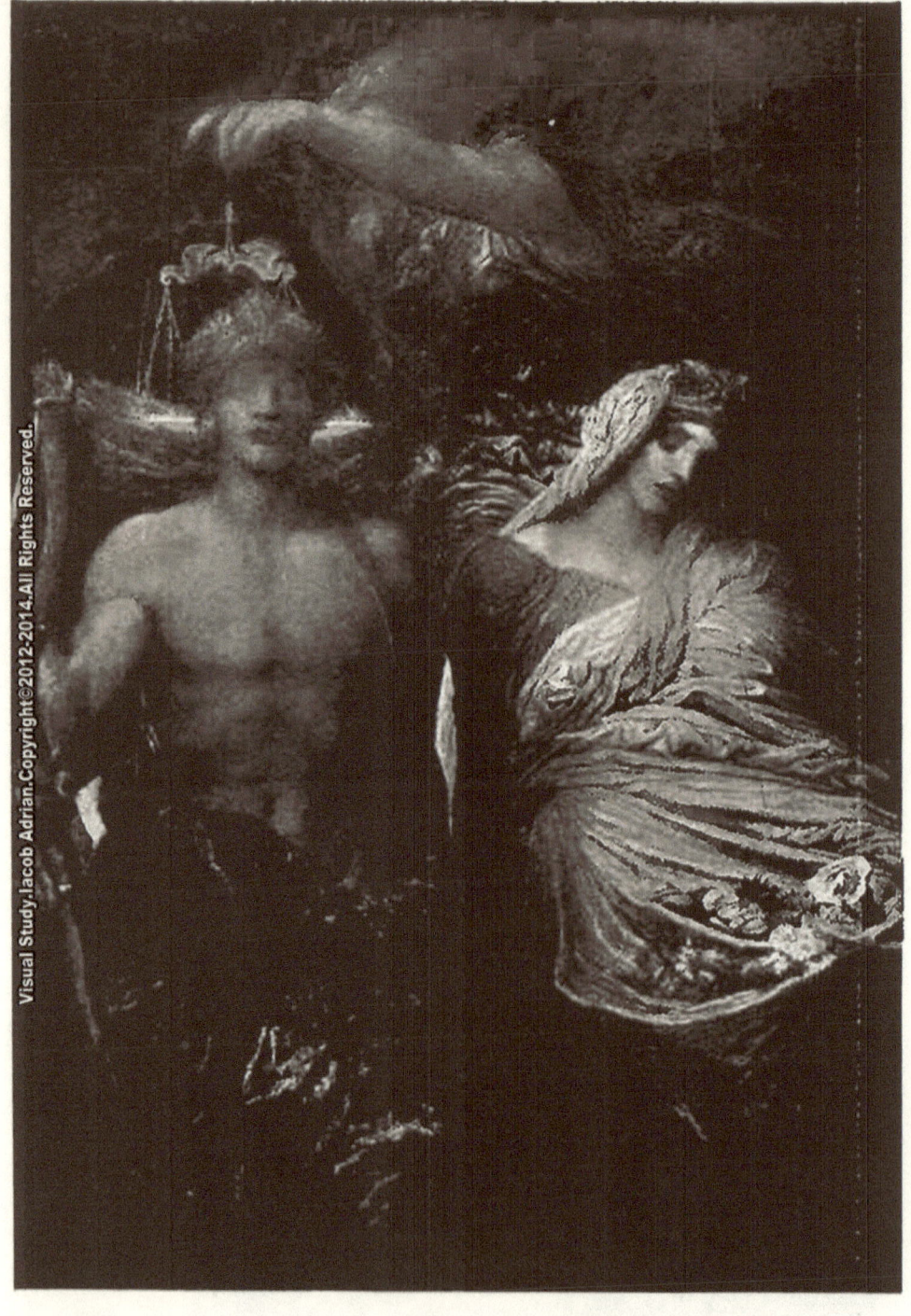

TIME, DEATH AND JUDGEMENT — LE TEMPS, LA MORT ET LE JUGEMENT — ZEIT, TOD UND GERICHT
(*St. Paul's Cathedral, London*) F. Hollyer, Photo.

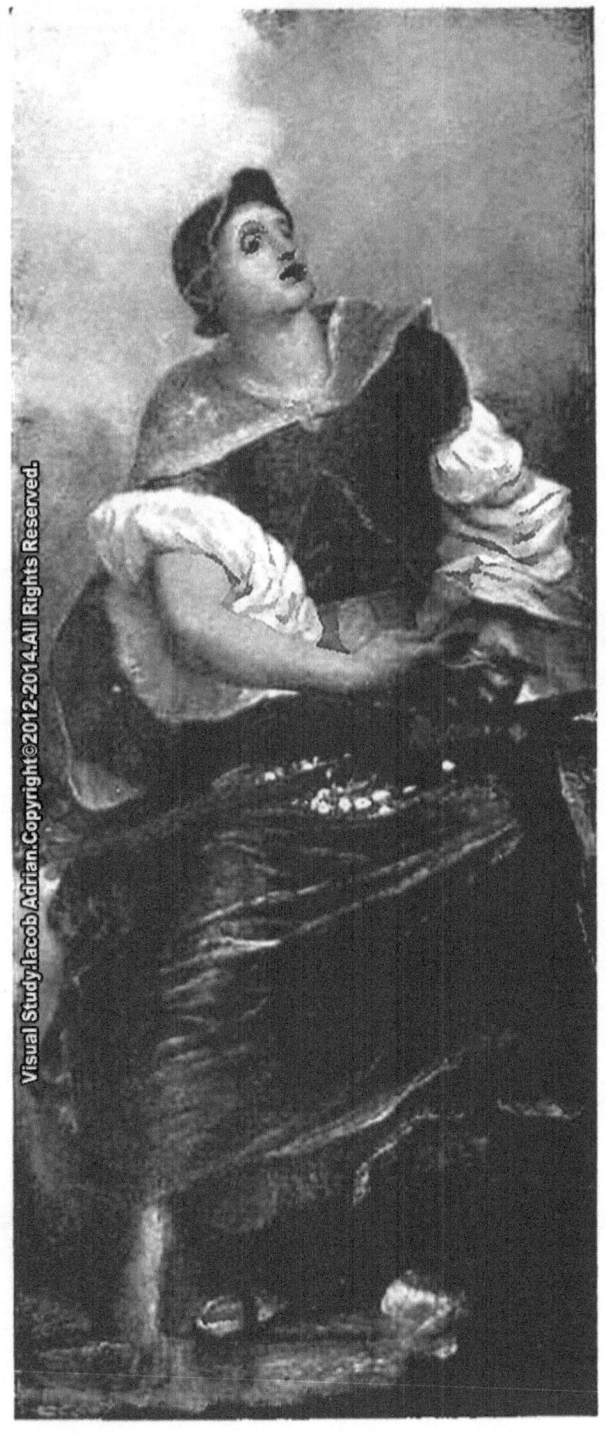

FAITH DER GLAUBE LA FOI
(*Tate Gallery, London*)
F. Hollyer, Photo.

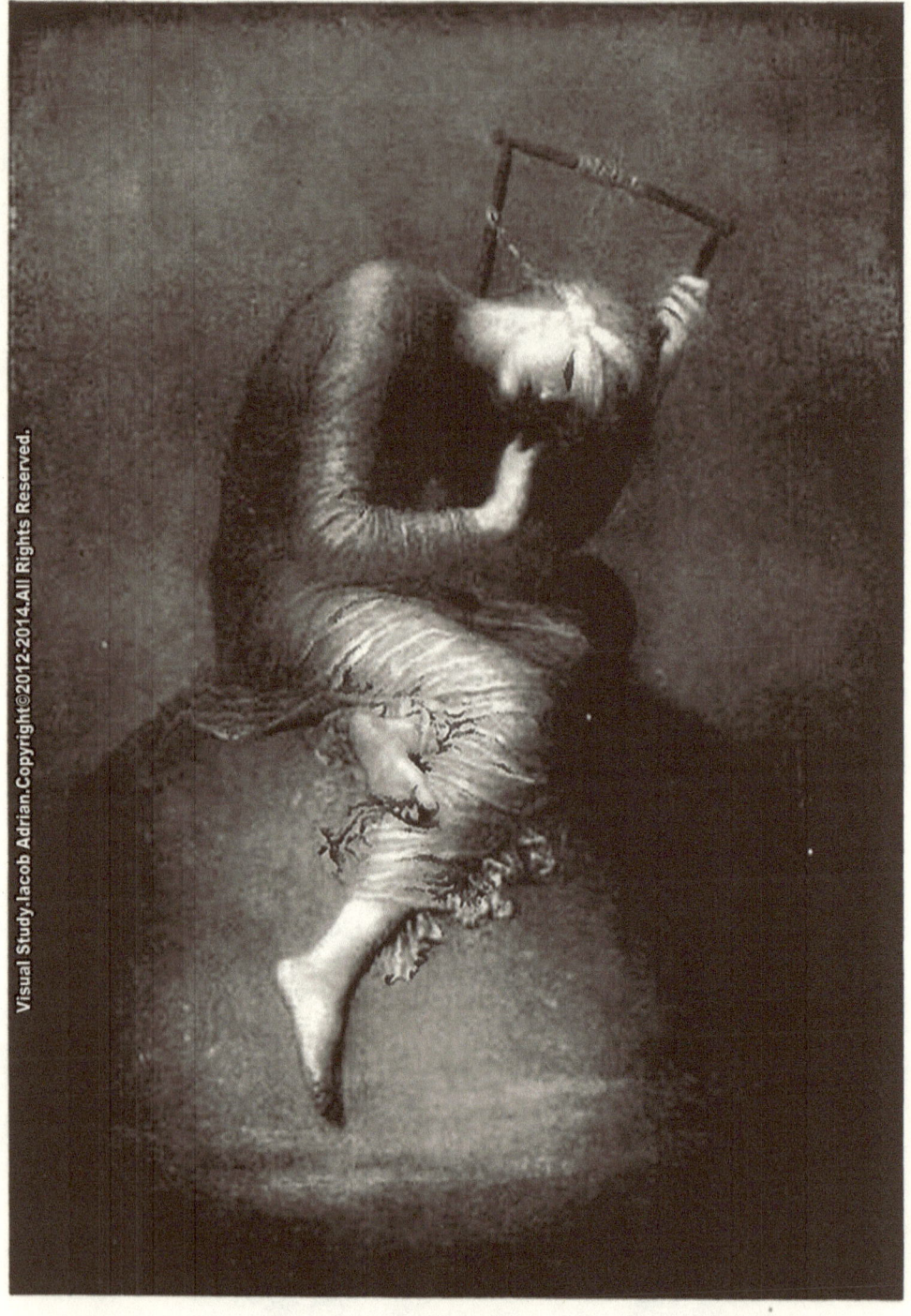

Hope Die Hoffnung L'Espérance
(Tate Gallery, London)
F. Hollyer, Photo.

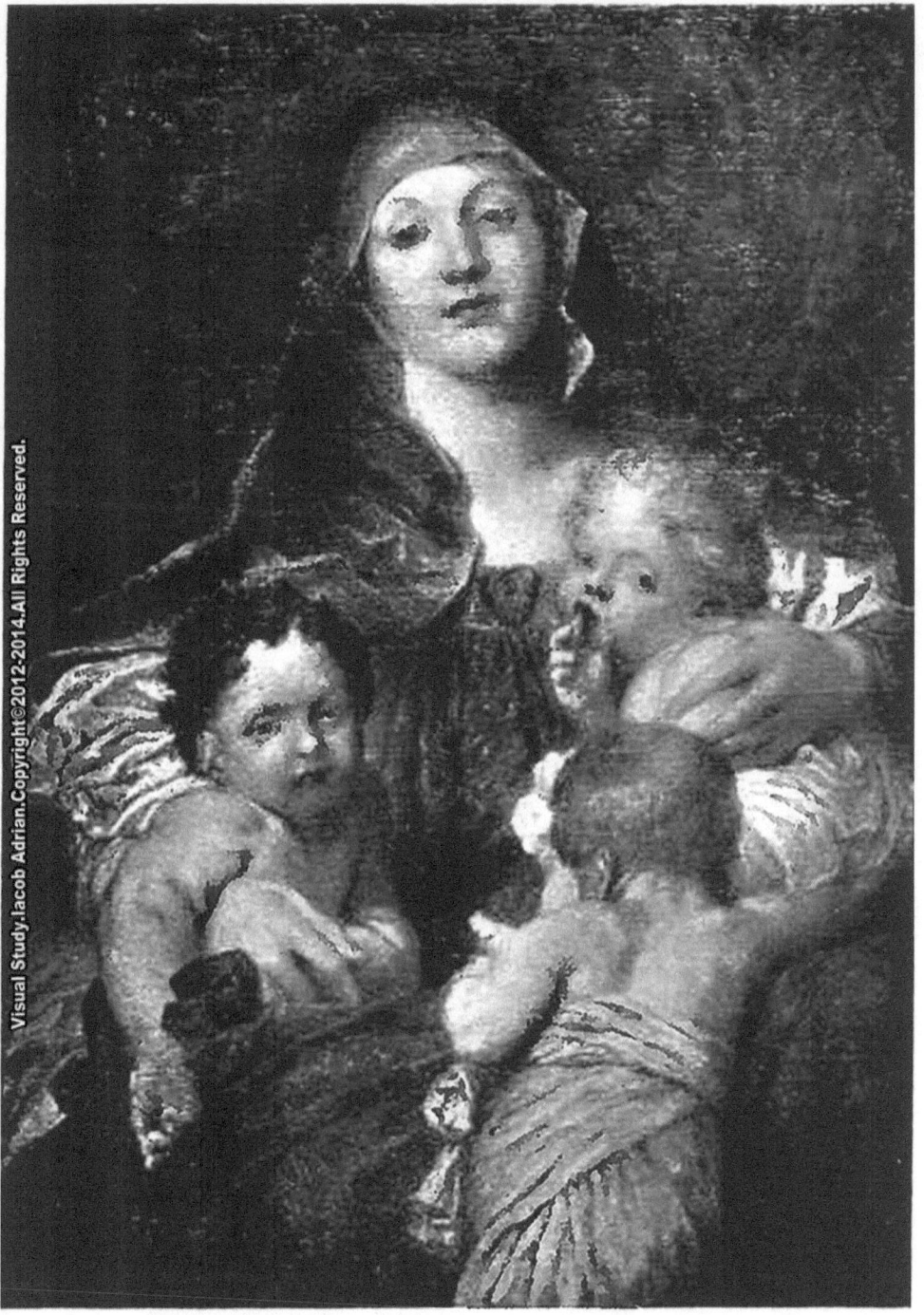

CHARITY DIE BARMHERZIGKEIT LA CHARITÉ
(*Mr. John Reid, Glasgow*)
F. Hollyer, Photo.

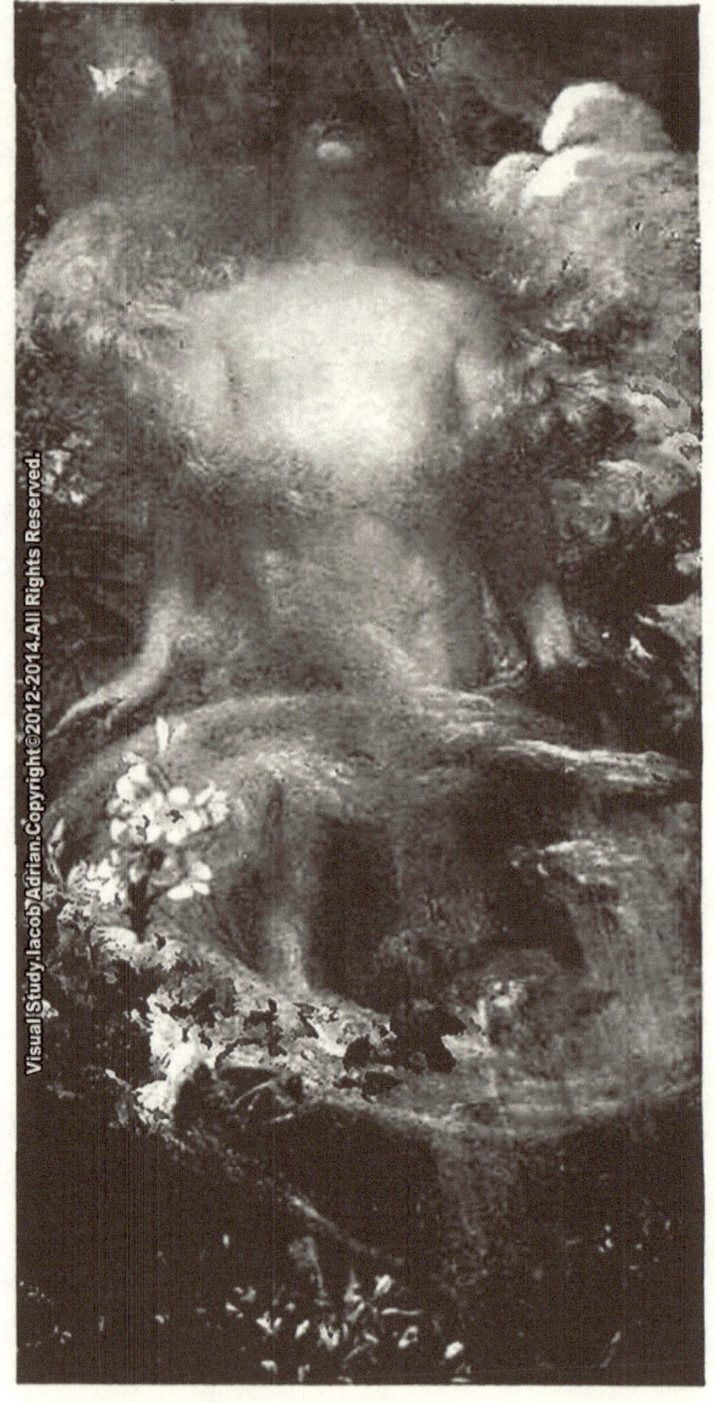

"HE SHALL BE CALLED WOMAN" "CELUI-CI S'APPELLERA D'UN NOM QUI MARQUE L'HOMME"
"MAN WIRD SIE MÄNNIN HEISSEN"
(Tate Gallery, London) F. Hollyer, Phot.

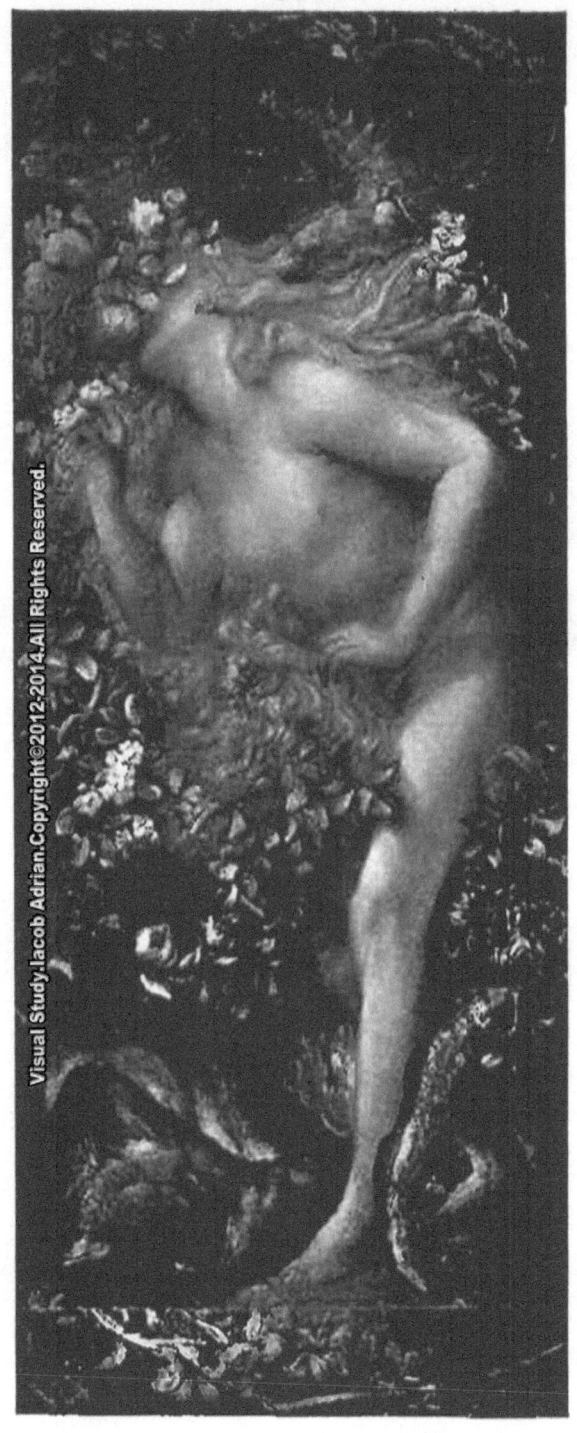

EVE TEMPTED ÈVE TENTÉE
EVA IN VERSUCHUNG
Watts Gallery, Compton, Guildford) F. Hollyer, Photo.

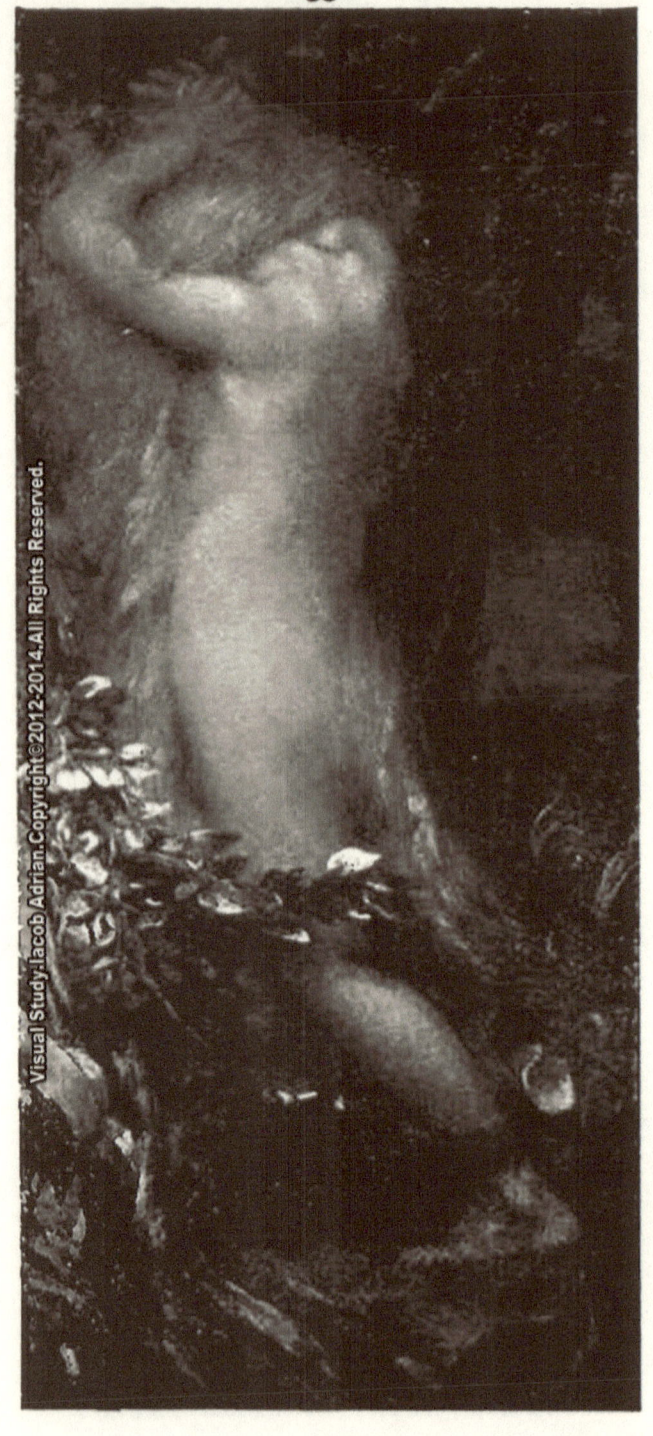

EVE REPENTANT ÈVE REPENTANTE
DIE BÜSSENDE EVA
(*Tate Gallery, London*) F. Hollyer, *Photo.*

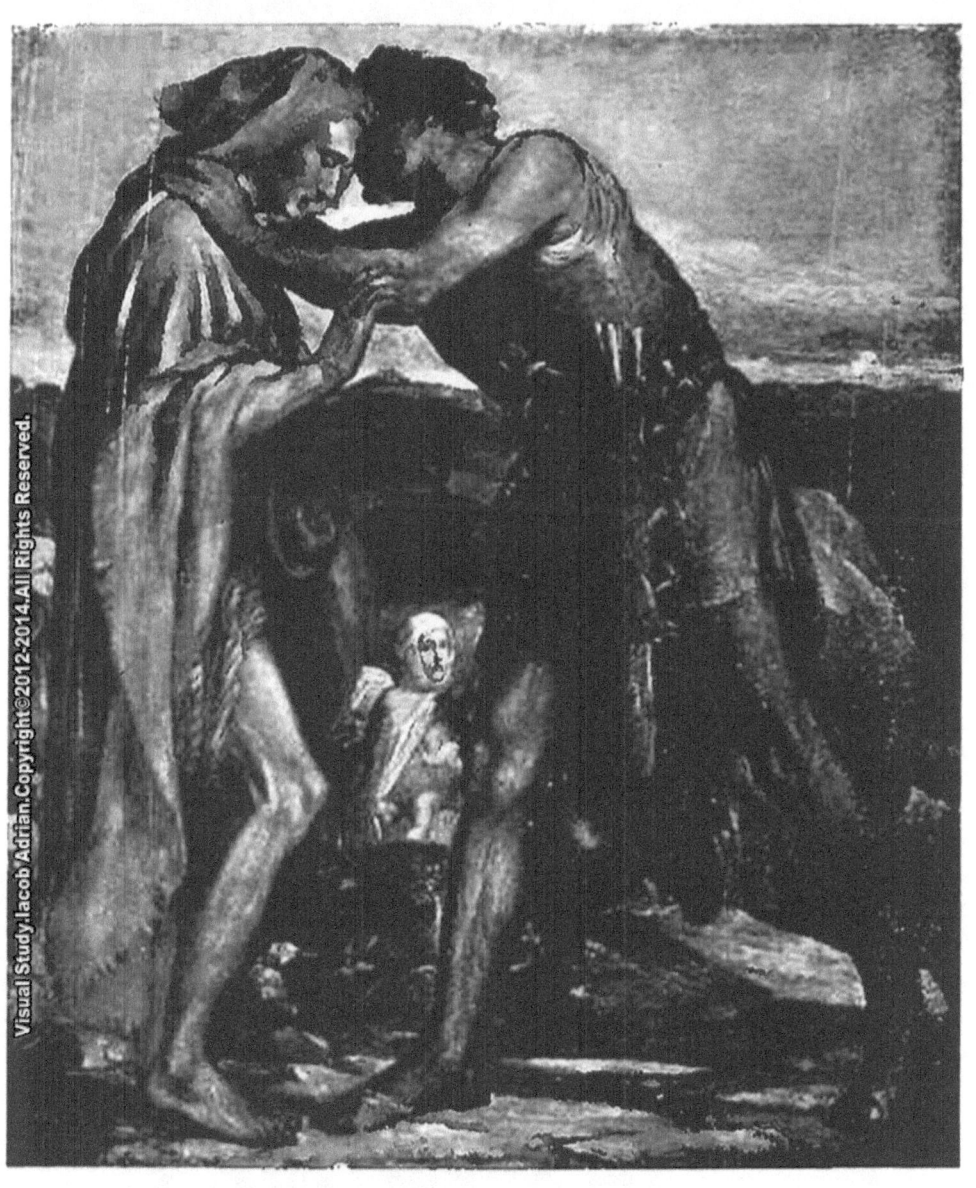

THE MEETING OF JACOB AND ESAU

RENCONTRE DE JACOB ET D'ÉSAÜ

BEGEGNUNG JAKOBS MIT ESAU

(Watts Gallery, Compton, Guildford)

F. Hollyer, Photo.

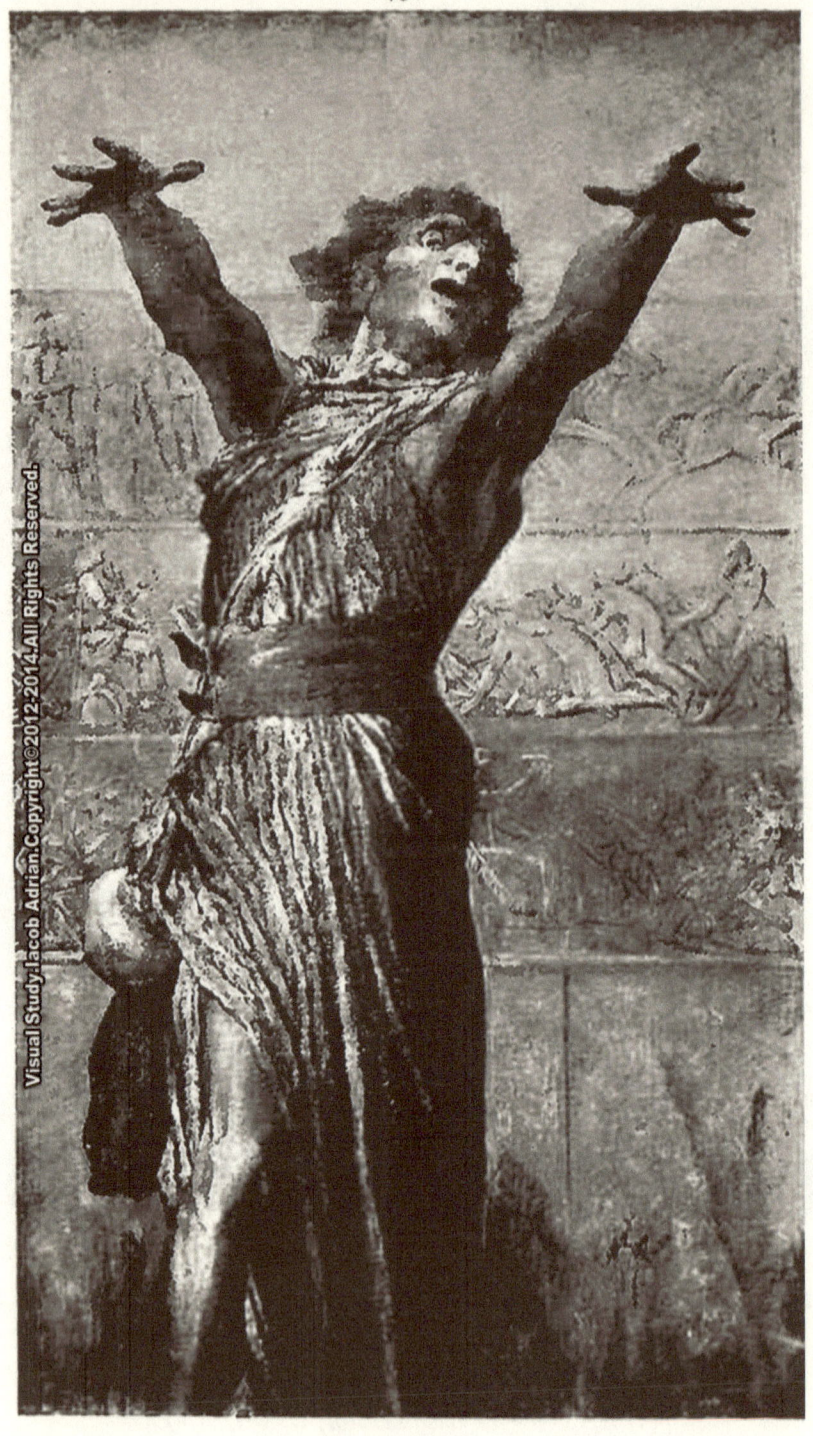

JONAH JONA JONAS
(Tate Gallery, London)
F. Hollyer, Photo.

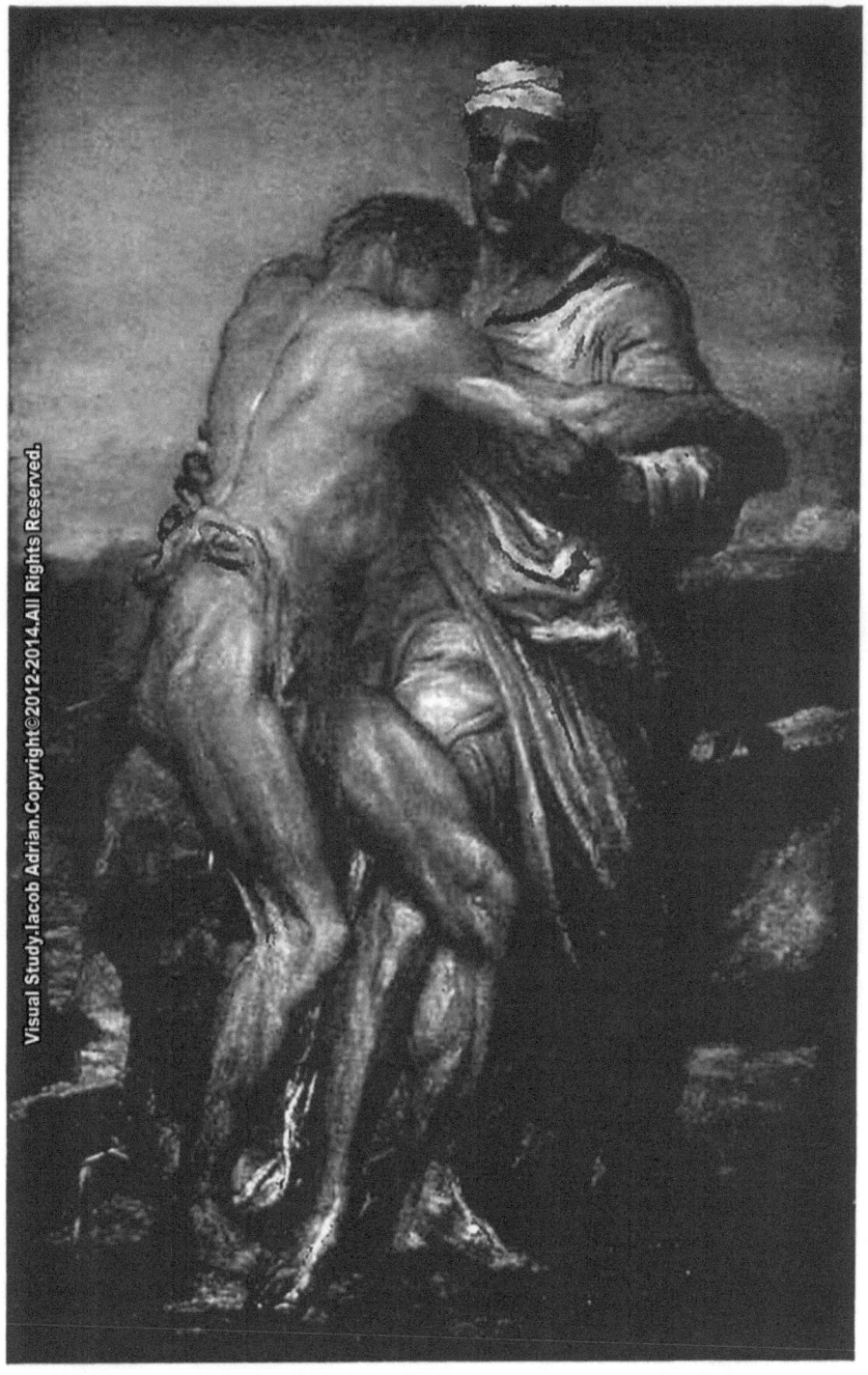

THE GOOD SAMARITAN — LE BON SAMARITAIN
DER BARMHERZIGE SAMARITER
(Watts Gallery, Compton, Guildford) — F. Hollyer, Photo.

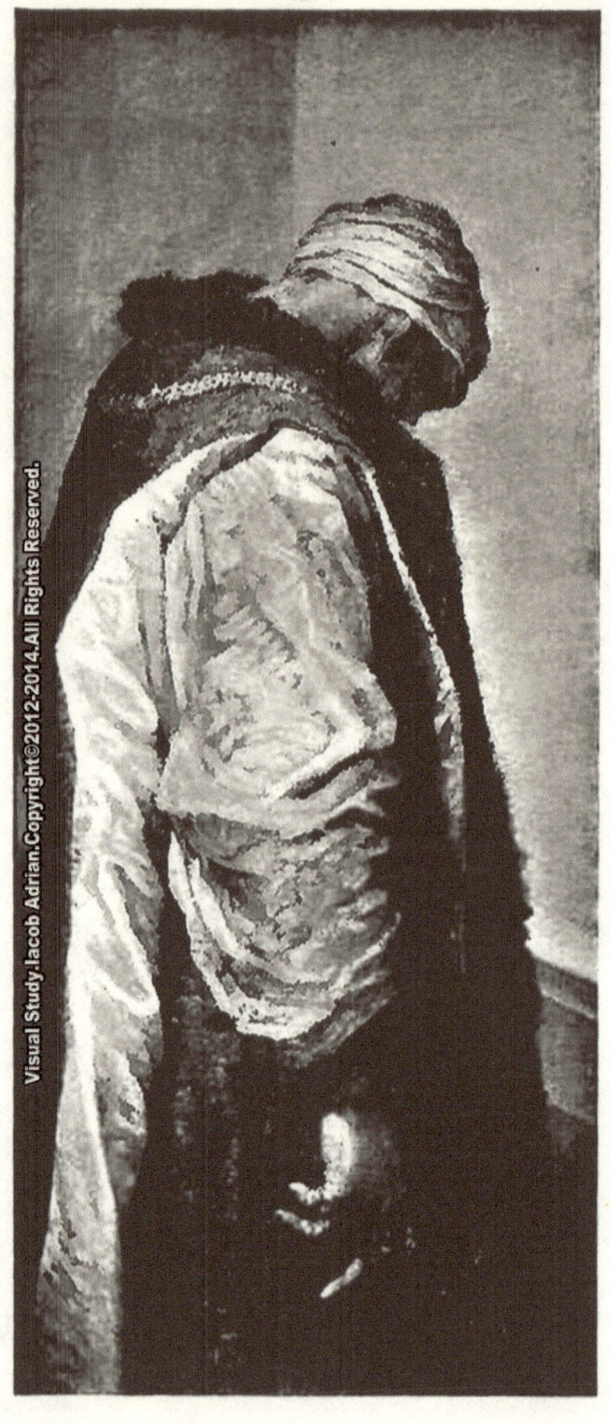

"For he had great Possessions" "Car il avait de grands Biens"
"Denn er hatte viel Güter"
(Tate Gallery, London) F. Hollyer, Photo.

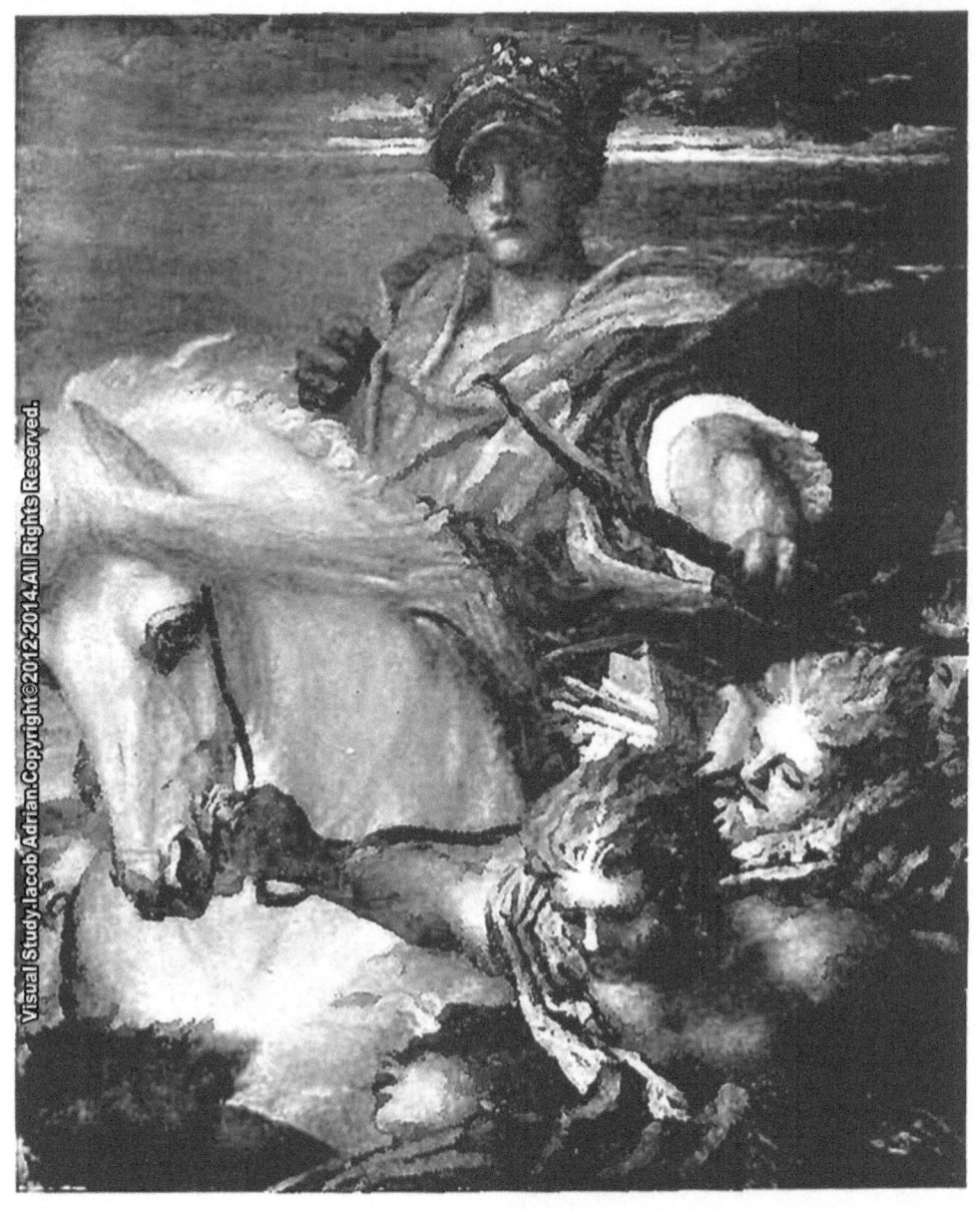

THE RIDER ON THE WHITE HORSE LE CAVALIER SUR LE CHEVAL BLANC
DER REITER AUF DEM WEISSEN PFERDE
(Hon. Alfred Talbot, Gt. Berkhampstead)
F. Hollyer, Photo.

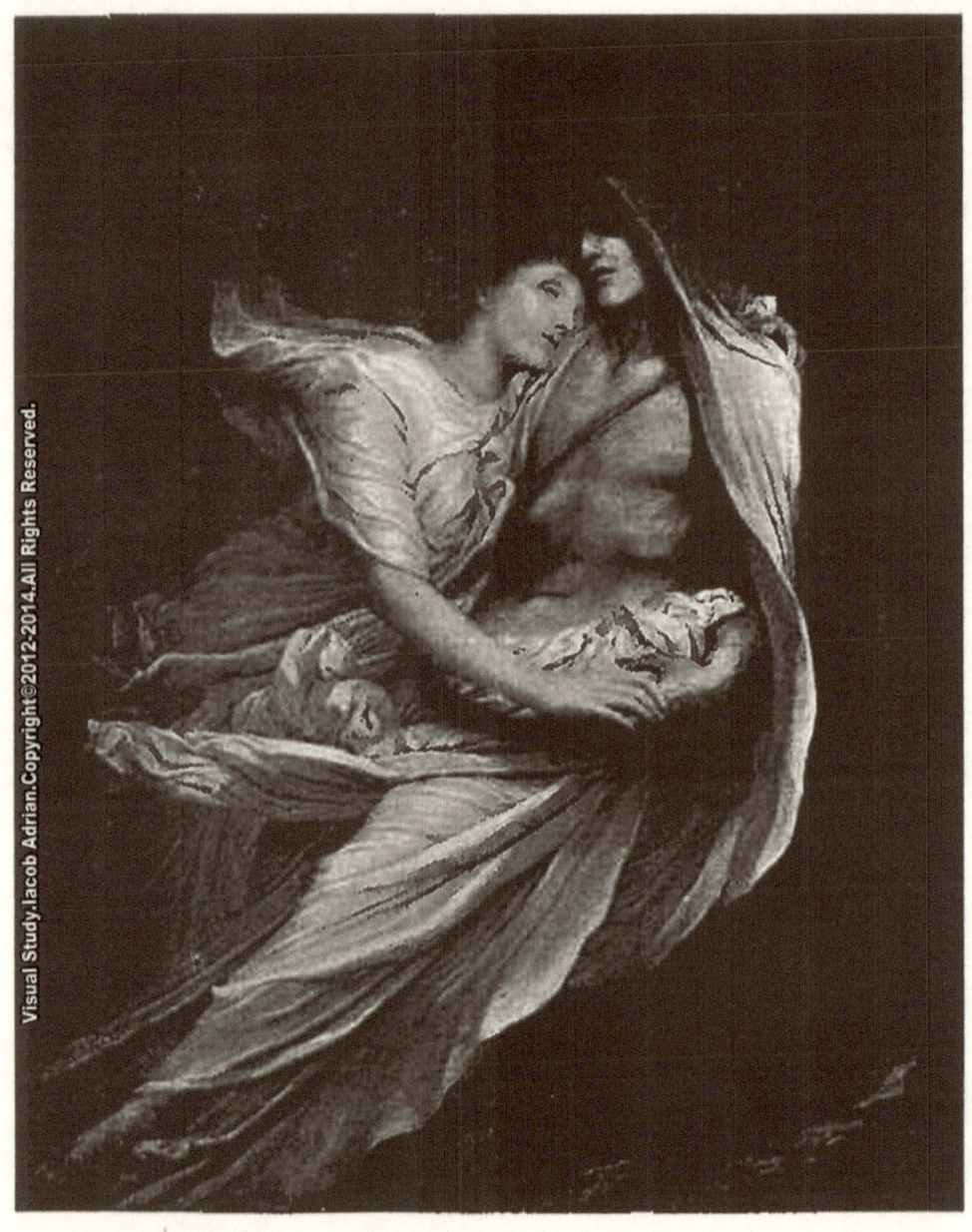

PAOLO AND FRANCESCA PAOLO ET FRANCESCA
PAOLO UND FRANCESCA
(*Watts Gallery, Compton, Guildford*)
F. Hollyer, Photo.

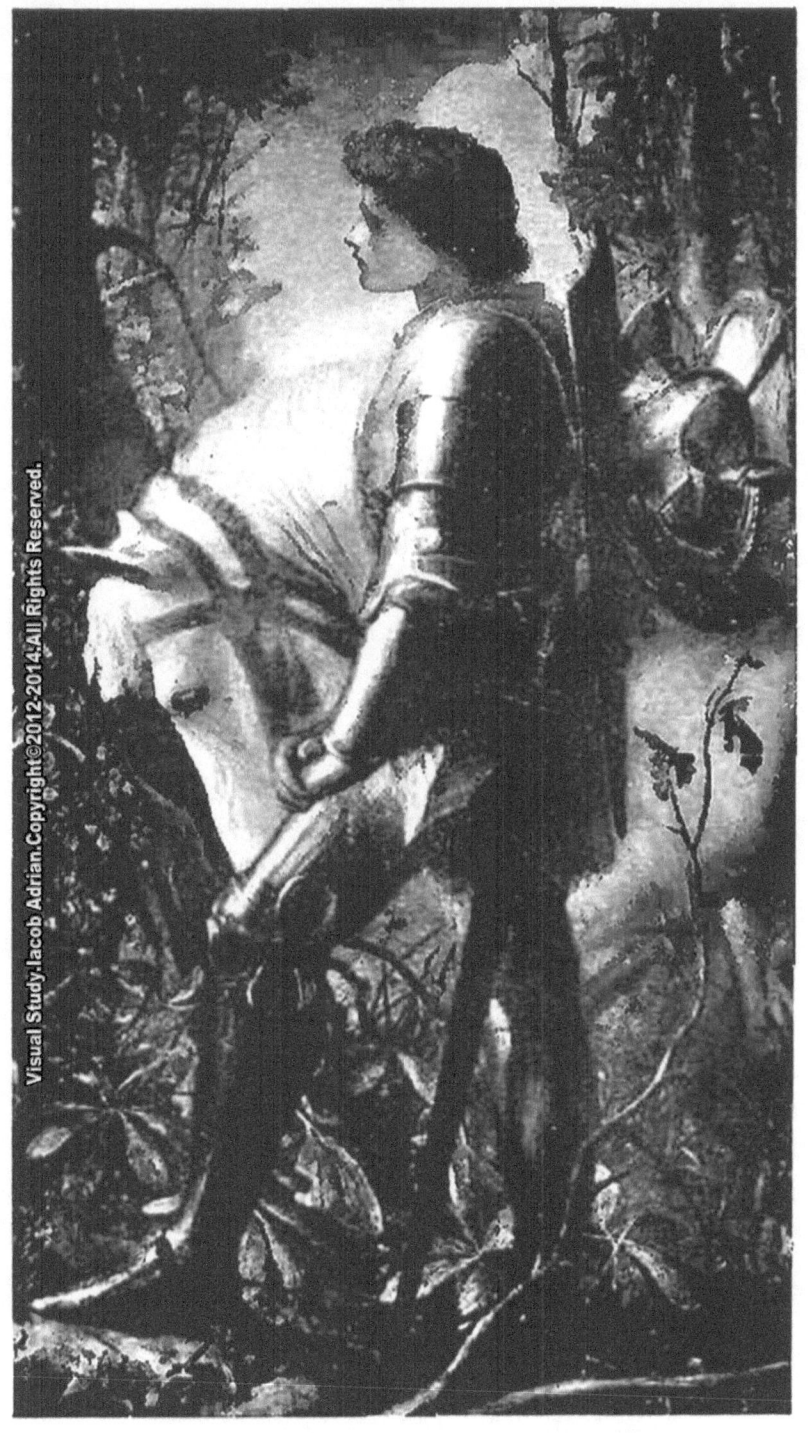

SIR GALAHAD
(*Sir Alex. Henderson, Bart., London*)
F. Hollyer, Photo.

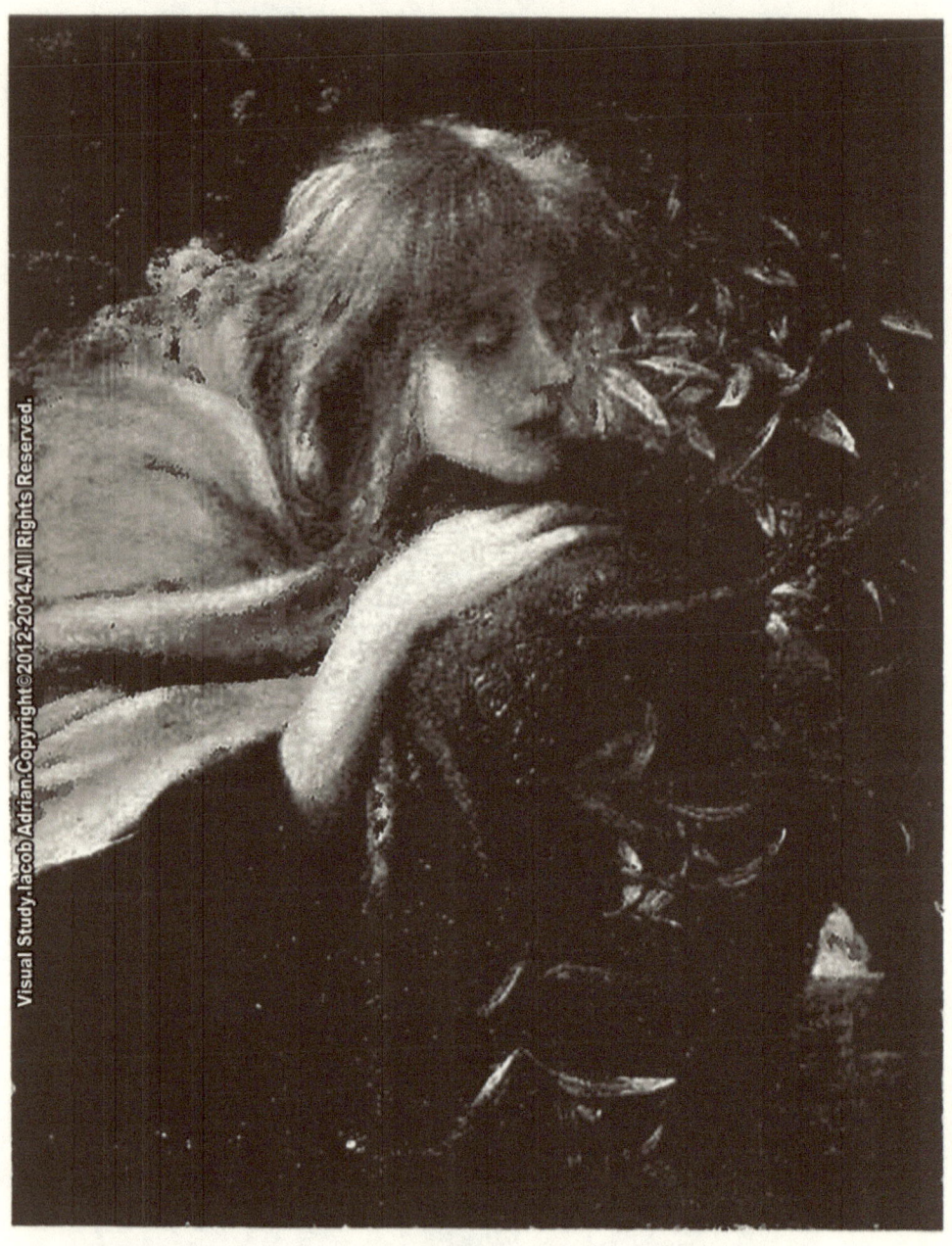

OPHELIA OPHELIA OPHÉLIE
(Watts Gallery, Compton, Guildford)
F. Hollyer, Photo.

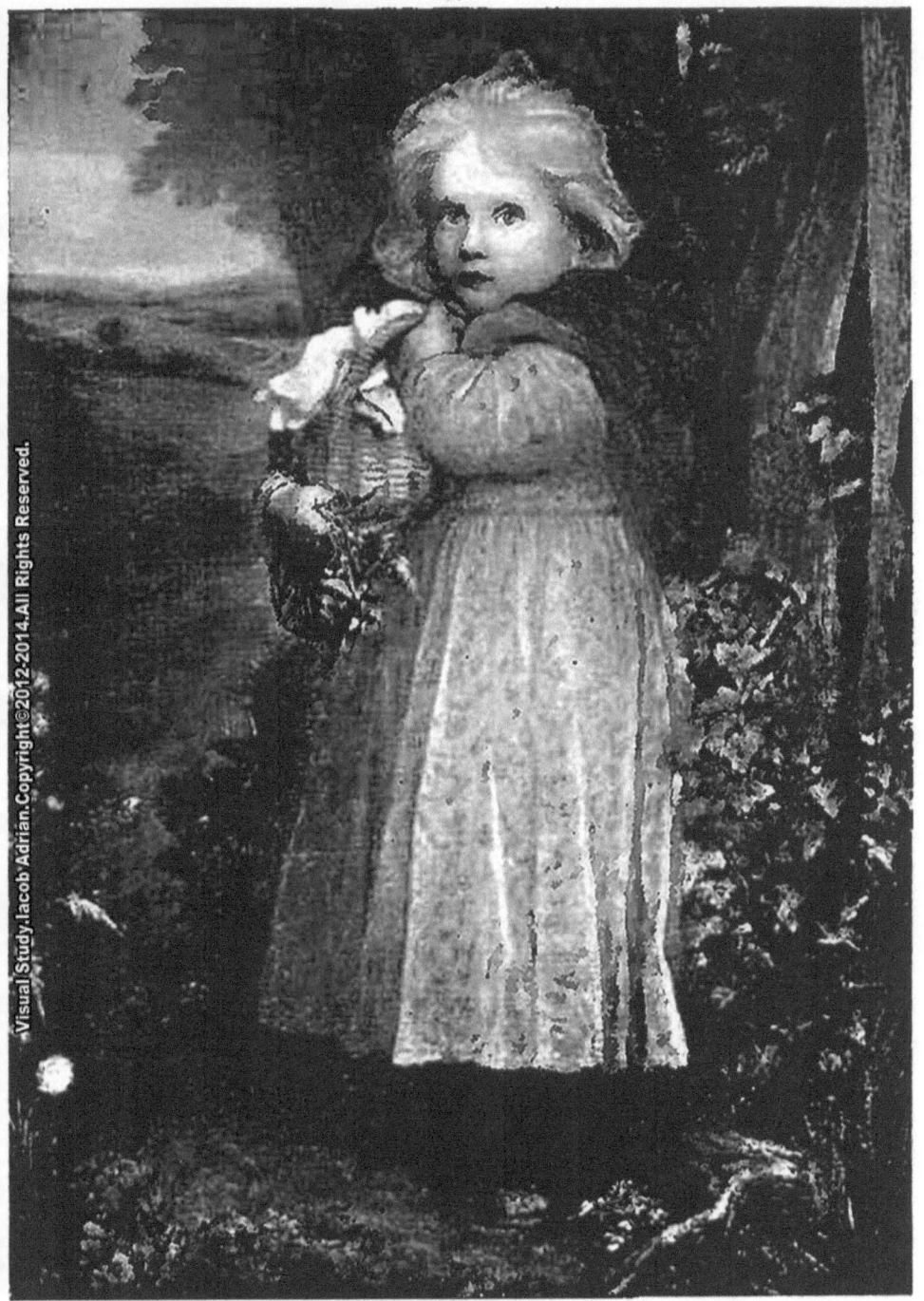

LITTLE RED RIDING-HOOD LE PETIT CHAPERON ROUGE
ROTKÄPPCHEN
(*Art Gallery, Birmingham*)
F. Hollyer, Photo.

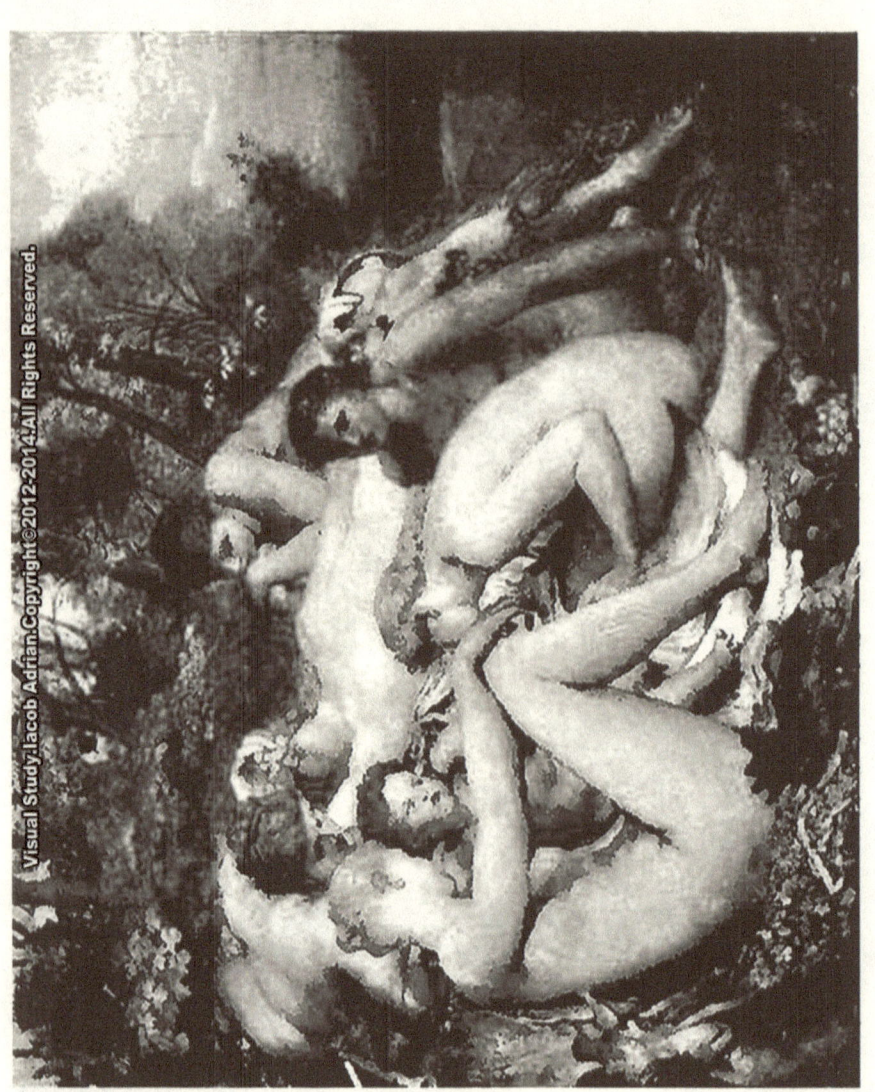

The Childhood of Zeus — L'Enfance de Zeus
Die Kindheit des Zeus

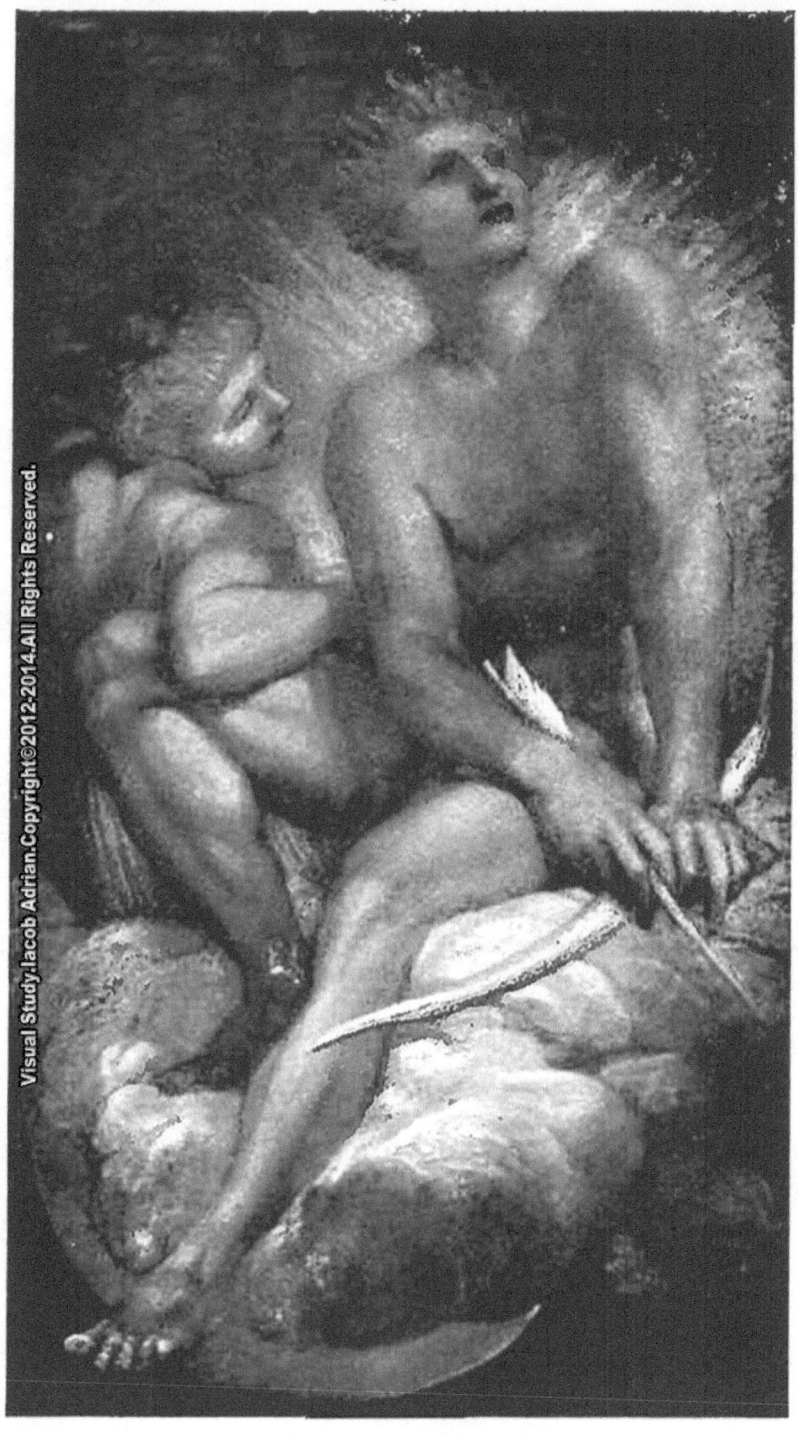

HYPERION
(*Watts Gallery, Compton, Guildford*)
F. Hol'yer, Photo.

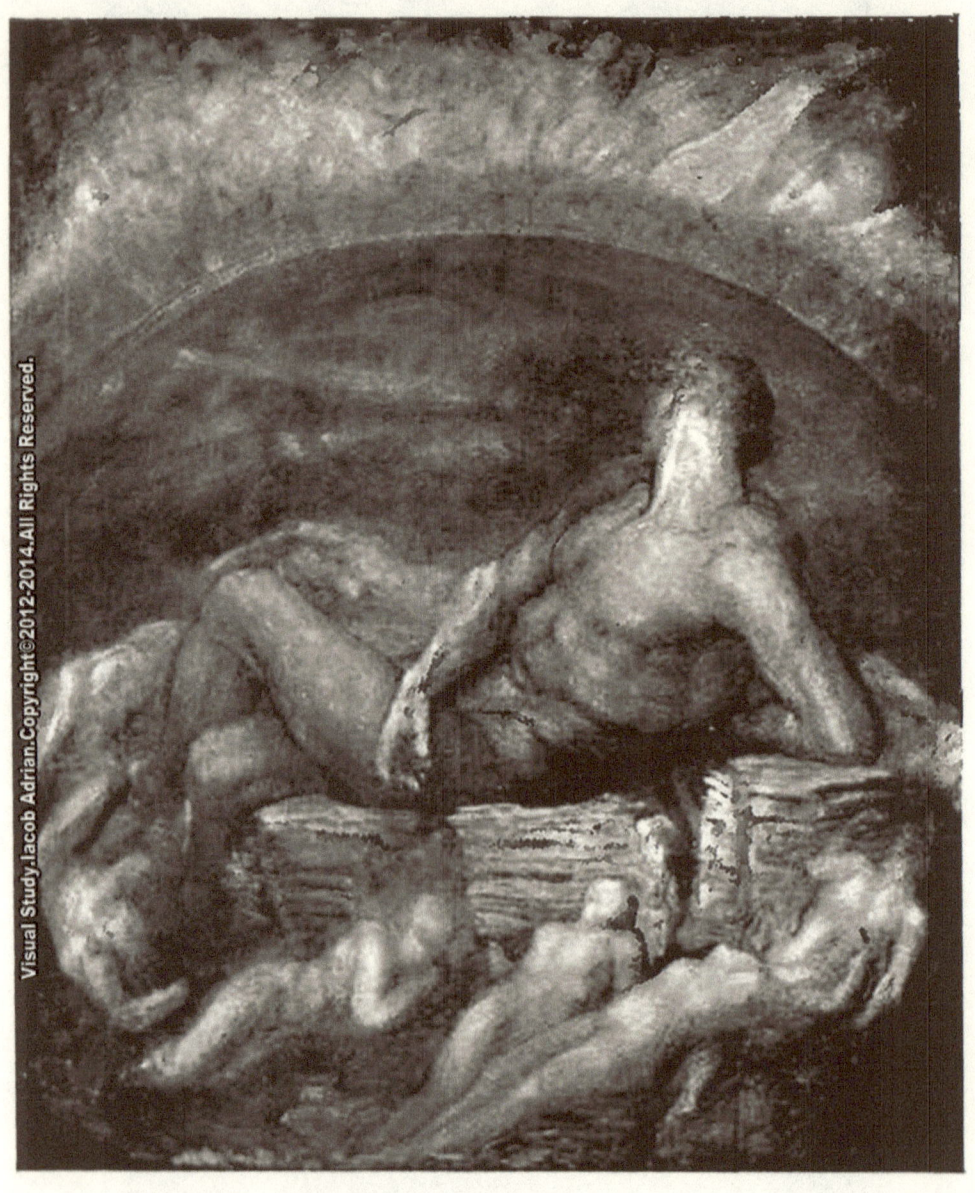

PROMETHEUS PROMETHEUS PROMÉTHÉE
(Watts Gallery, Compton, Guildford)
F. Hollyer, Photo.

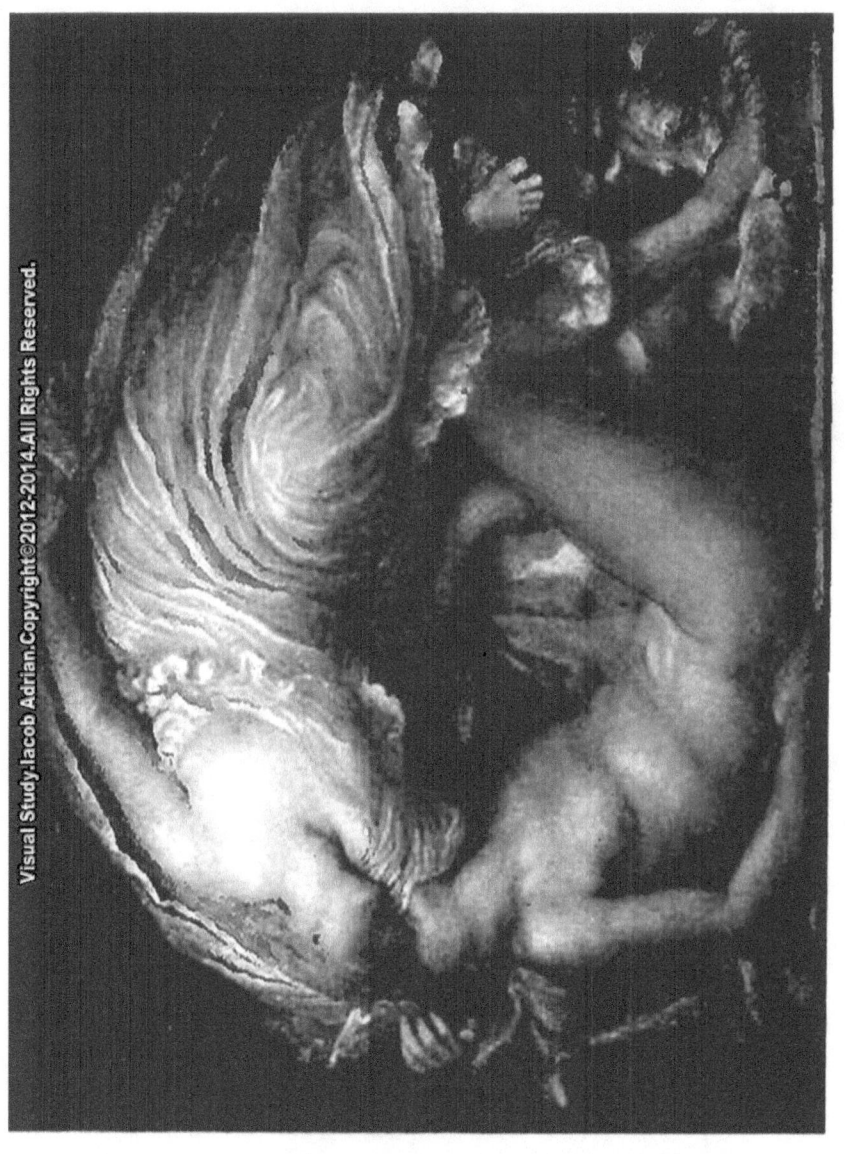

ENDYMION
(*Lord Glenconner, London*)
F. Hollyer, Photo.

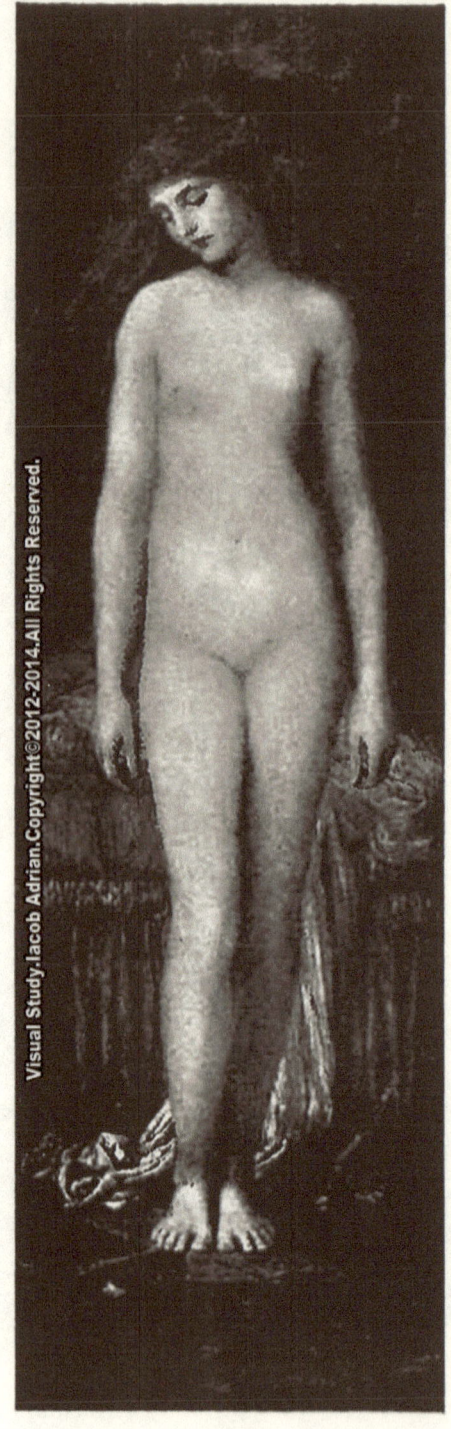

PSYCHE
(*Tate Gallery, London*)
F. Hollyer, Photo.

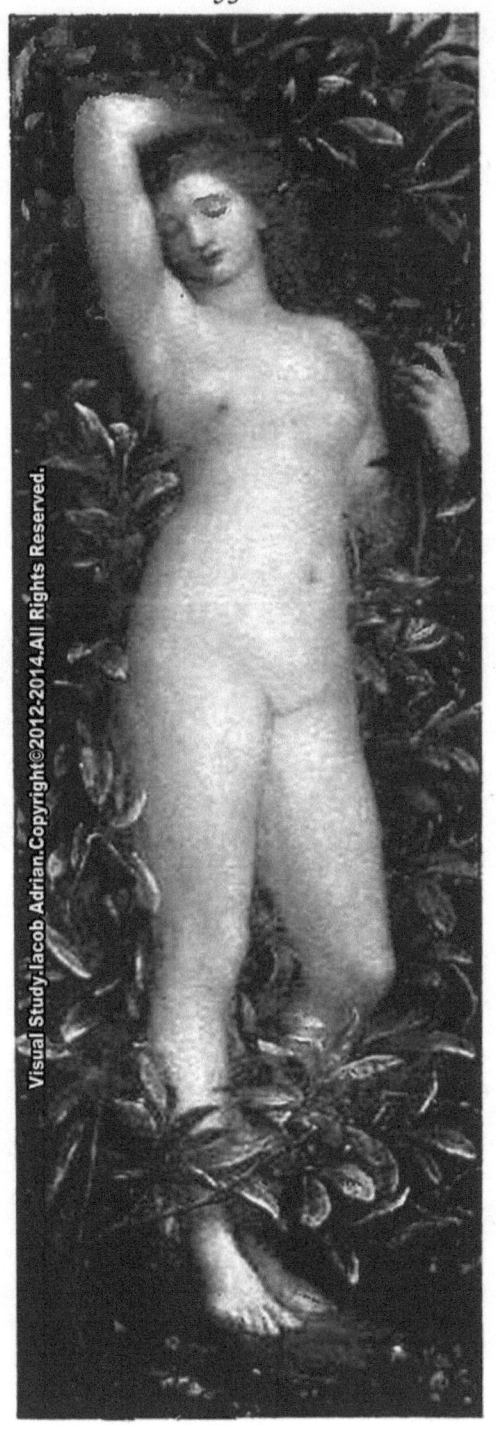

DAPHNE
(Sir W. H. Lever, Bart., Thornton Hough)
F. Hollyer, Photo.

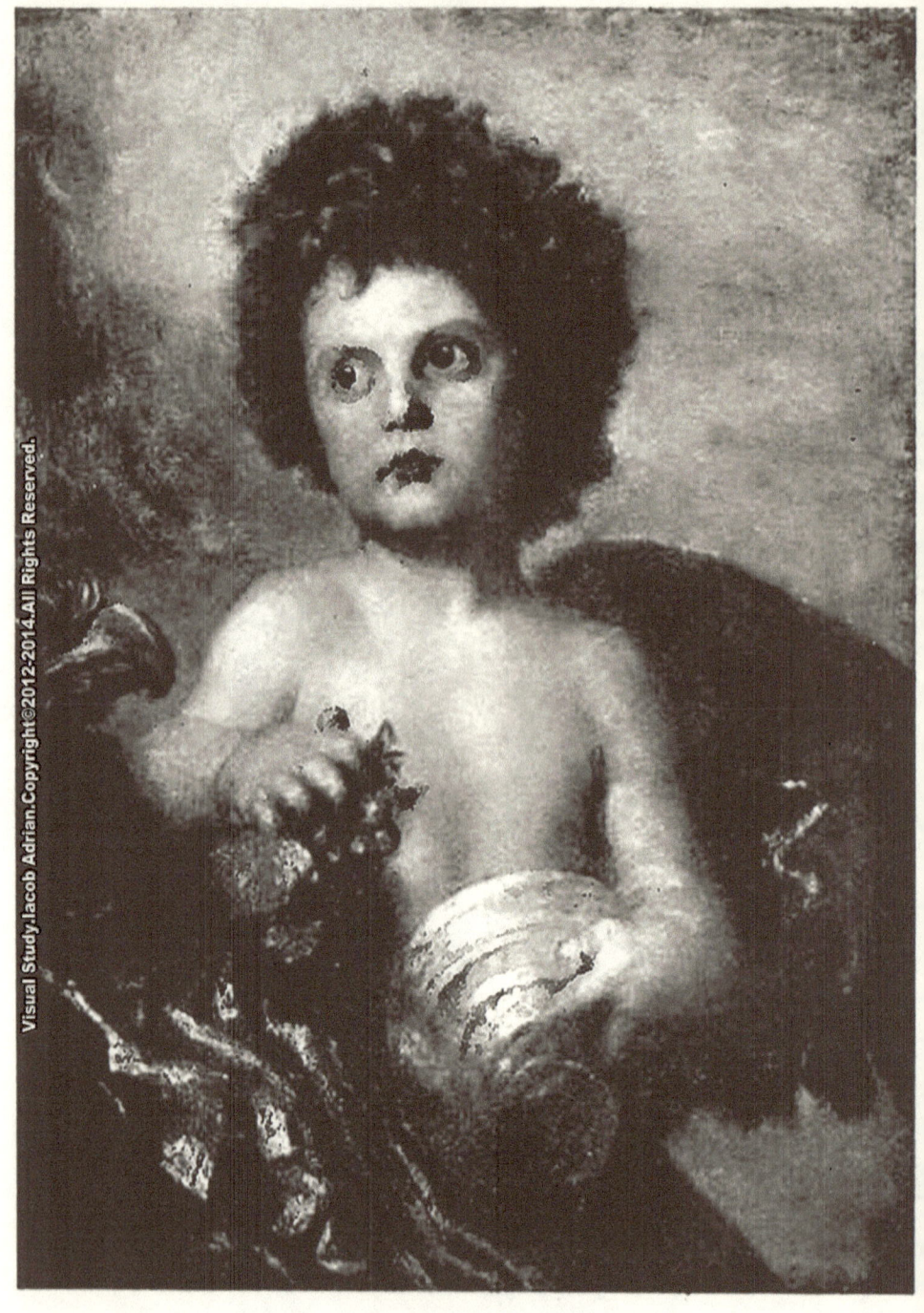

GANYMEDE GANYMED GANYMÈDE
(*Mr. Henry F. Makins, London*)
F. Hollyer, Photo.

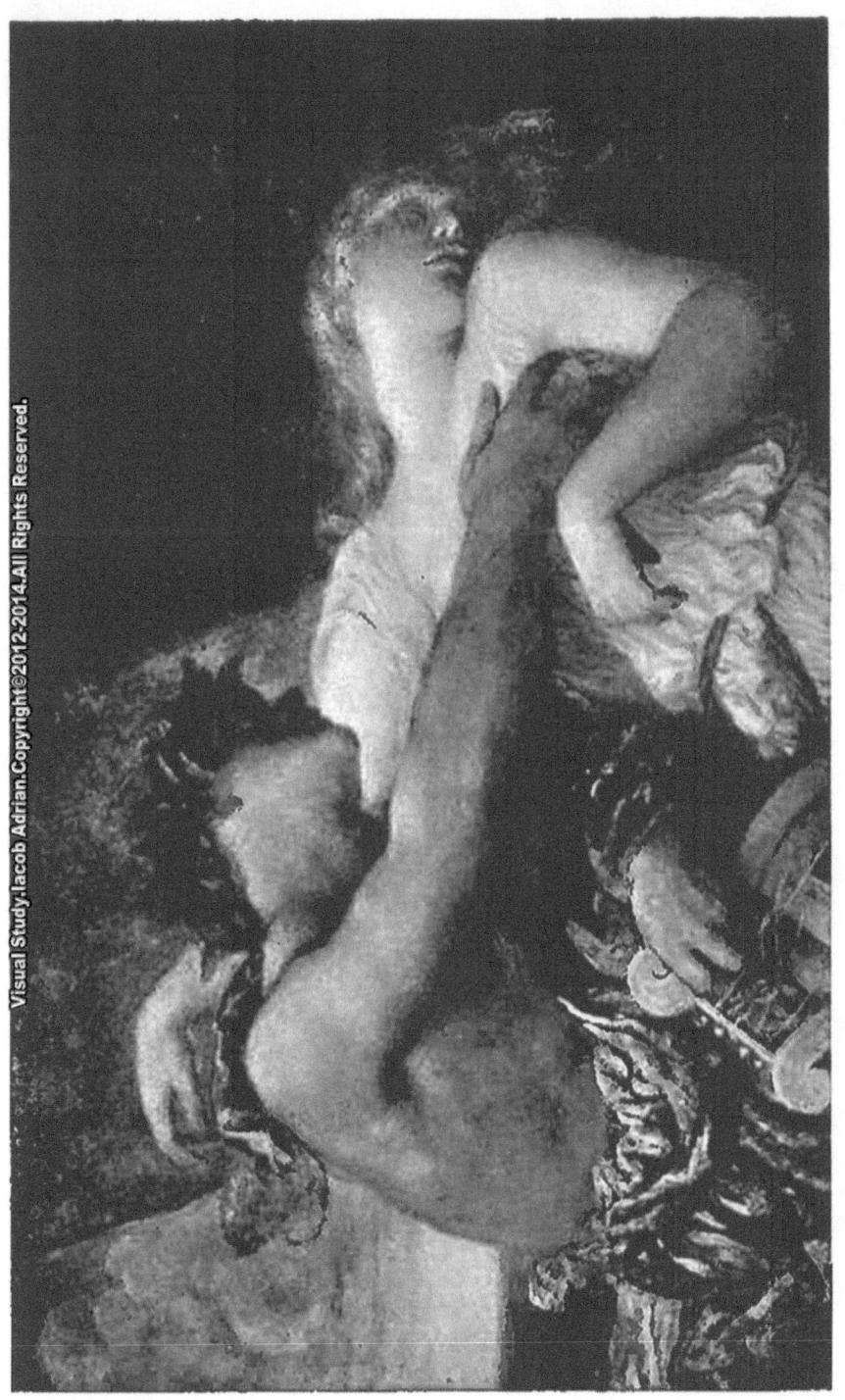

ORPHEUS AND EURYDICE ORPHEUS UND EURYDICE ORPHÉE ET EURYDICE
(Hon. Percy Wyndham, London)

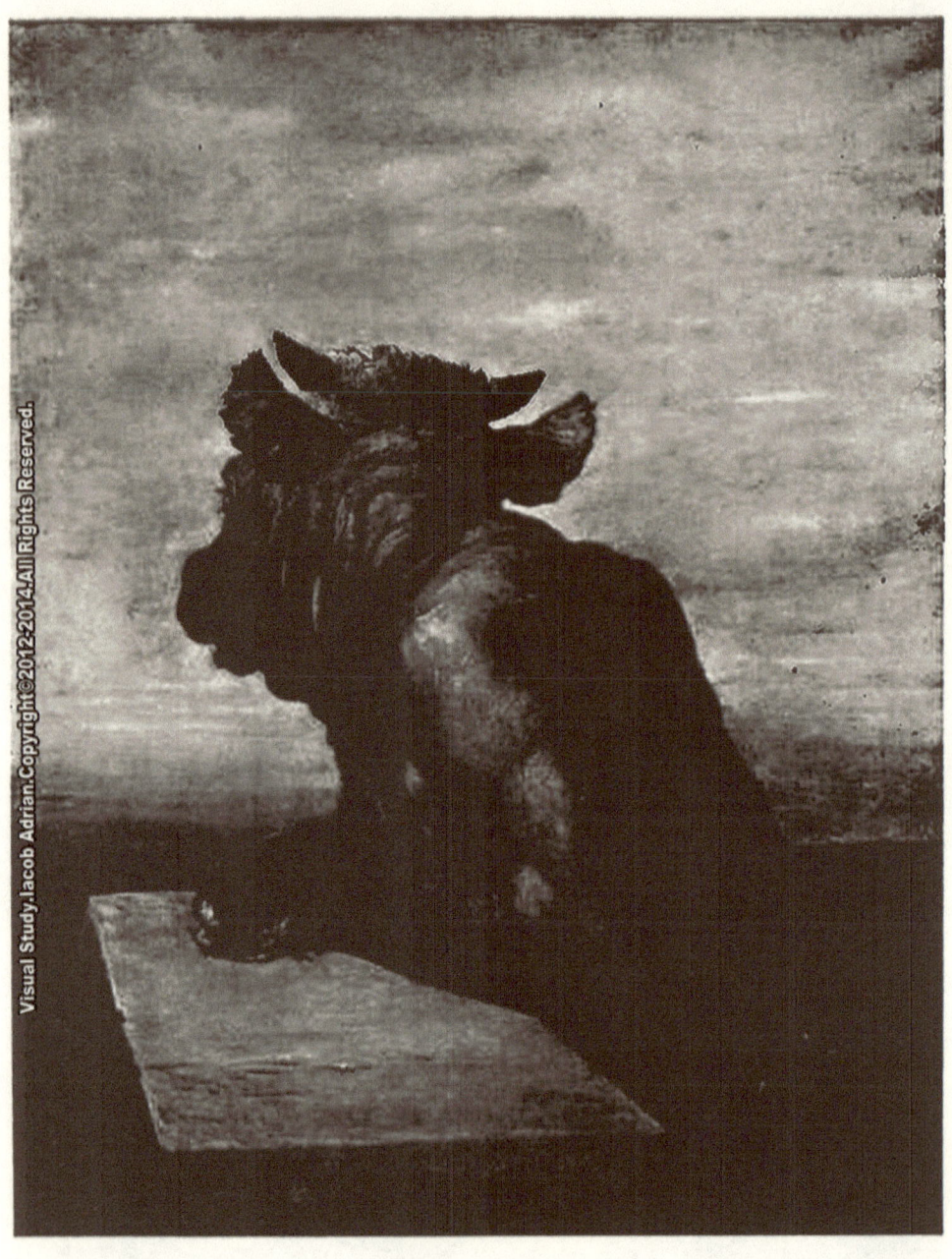

THE MINOTAUR DER MINOTAUR LE MINOTAURE
(Tate Gallery, London)
F. Hollyer, Photo.

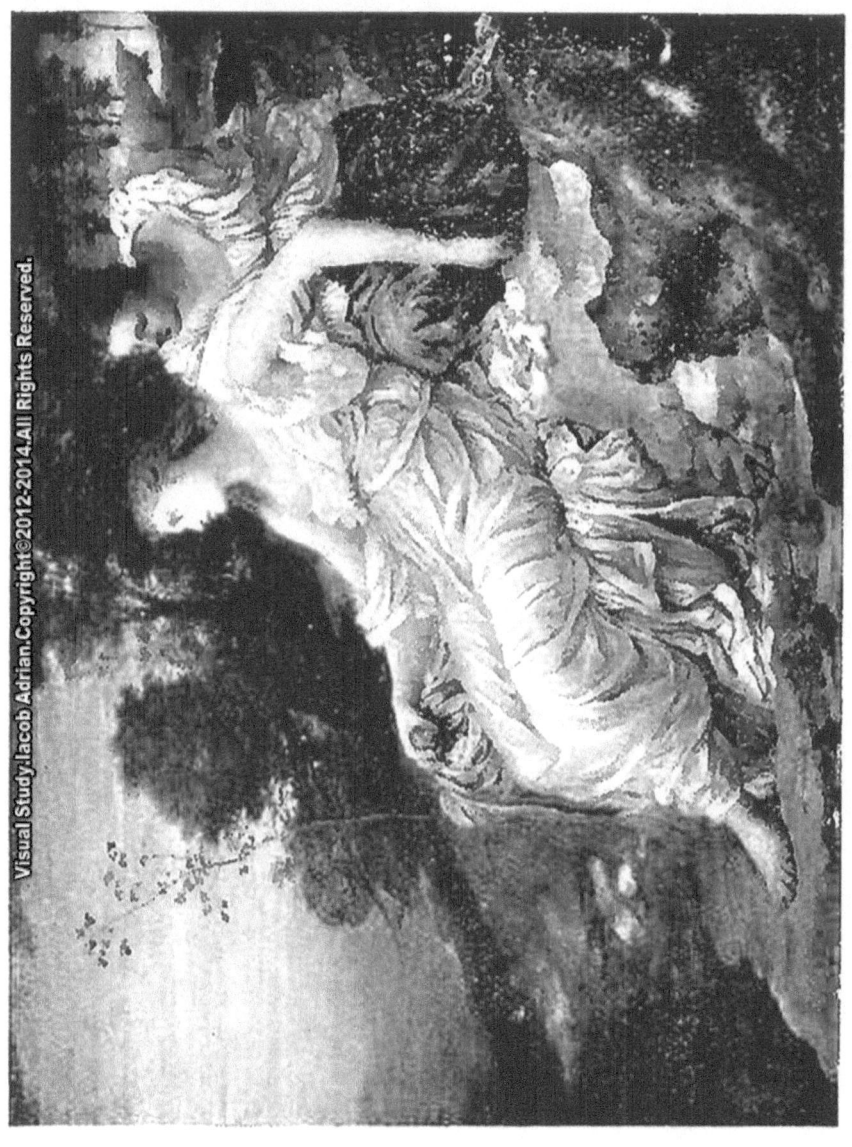

ARIADNE IN NAXOS ARIADNE AUF NAXOS ARIANE DANS L'ILE DE NAXOS
(Mr. C. Morland Agnew, London)
F. Hollyer, Photo.

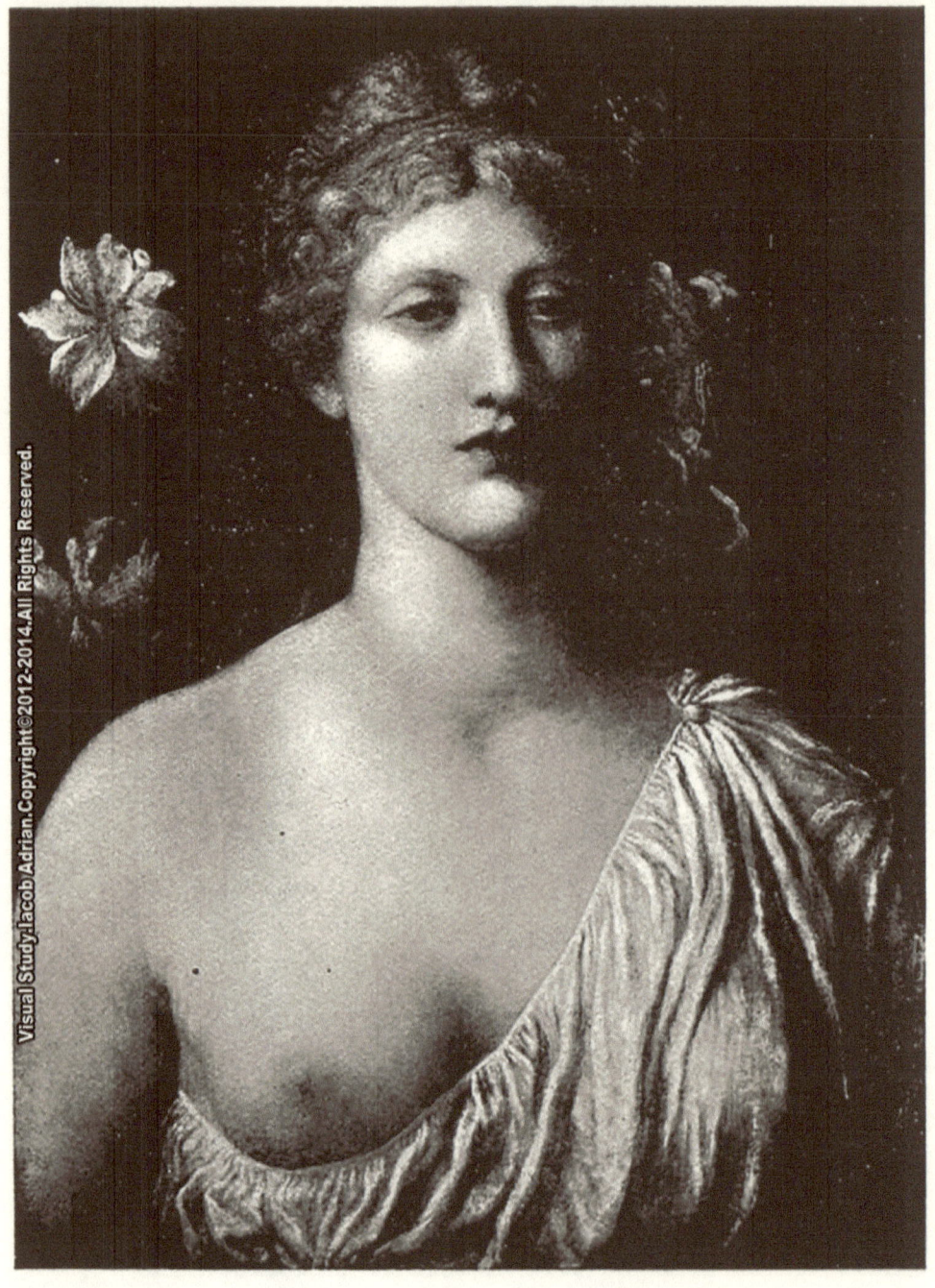

PYGMALION'S WIFE LA FEMME DE PYGMALION
PYGMALIONS FRAU
(Sir Alex. Henderson, Bart., London)
F. Hollyer, Photo.

A BACCHANAL. EIN BACCHANAL. UNE BACCHANALE.
(*Watts Gallery, Compton, Guildford*)
F. Hollyer, Photo.

Bibliographic sources :

Masterpieces of G.F. Watts (1911)

Author: Watts, George Frederick, 1817-1904

Publisher: London : Gowans & Gray

This documentary study use,
combined in various proportions,
elements from the following categories,
forms and subsets :
- fair use
- documentary
- documentary photography
- feature
- journalism
- arts journalism
- visual journalism
- photojournalism
- celebrity photography
in order to :
- employ material as the object of cultural critique ,
- quote to illustrate an argument or point ,
- use material in historical sequence,
providing independent opinion,
using photos, press articles, advertisements,
opinions of fans etc. ...

Copyright©2012-2014 Iacob Adrian
All Rights Reserved.

A BACCHANAL.　　　EIN BACCHANAL.　　UNE BACCHANALE
(*Watts Gallery, Compton, Guildford*)
F. Hollyer, Photo.

Bibliographic sources :

Masterpieces of G.F. Watts (1911)

Author: Watts, George Frederick, 1817-1904

Publisher: London : Gowans & Gray

This documentary study use,
combined in various proportions,
elements from the following categories,
forms and subsets :
- fair use
- documentary
- documentary photography
- feature
- journalism
- arts journalism
- visual journalism
- photojournalism
- celebrity photography
in order to :
- employ material as the object of cultural critique ,
- quote to illustrate an argument or point ,
- use material in historical sequence,
providing independent opinion,
using photos, press articles, advertisements,
opinions of fans etc. ...

Copyright©2012-2014 Iacob Adrian
All Rights Reserved.